Erotic Drawings

Page 4:
The Rest of the Volupté
François Boucher, 1748

Designed by:
Baseline Co Ltd
19-25 Nguyen Hue
District 1, Ho Chi Minh City
Vietnam

ISBN 1-84013-733-9

Published in 2004 by Grange Books
an imprint of Grange Books Plc
The Grange Kingsnorth Industrial Estate
Hoo, nr Rochester, Kent ME3 9ND
www.grangebooks.co.uk

Printed in China by Everbest Printing Co Ltd

Foreword

"Eroticism has its own moral justification because it says that pleasure is enough for me; it is a statement of the individual's sovereignty."

— Mario Vargas Llosa

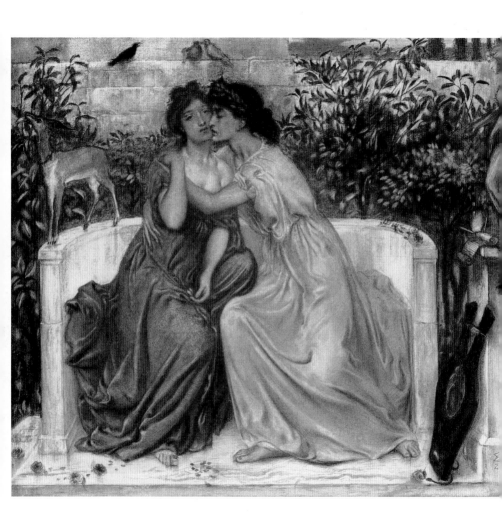

4

Contents

Paul Gauguin

Rodin

Degas

Félicien Rops

PICASSO

Gustav Klimt

EGON
SCHIELE

The term 'Erotic Art' is surrounded by a halo of hypocritical, misleading and dissimulating concepts. Art or pornography, sexuality or eroticism, obscenity or originality: all of these attempts of distinction and determination are so meddled that it seems almost impossible to reach an objective definition. From what point can one speak of "erotic art"?

Scherzo

———

Michelangelo, c. 1512
Doria-Pamphili Collection, Rome

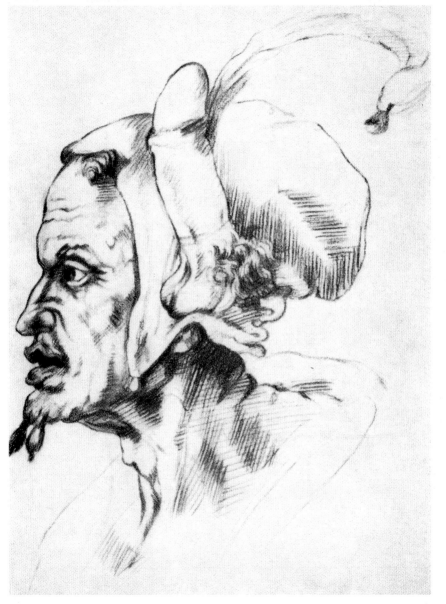

9

Every collector of erotic art has been at some point presented with works esteemed as insufficient from every point of view, while he expected something better. Still, the seller would affirm that he had found an important object of the erotic genre. But sometimes it seems that the eye becomes stupefied when in contact with this free subject.

Joseph and Potiphar's Wife

Rembrandt van Rijn, 1634
etching, 9 x 11.5 cm

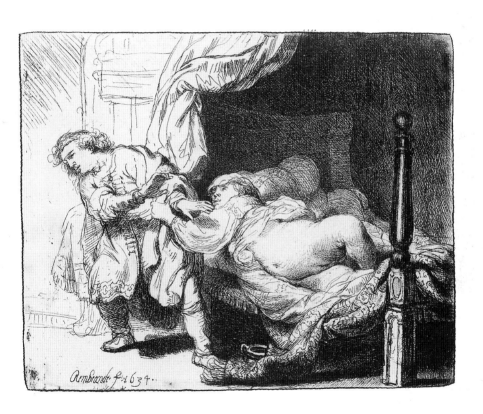

Rembrandt f. 1634

In order to be convinced of this, one simply needs to think of a man, often very cultivated, who considers as important a work of poor artistic value. On the other hand, it often so happens that a masterpiece will be considered as futile because of its subject.

The Monk in the Wheatfield

Rembrandt van Rijn, 1646
The Art Institute of Chicago, Chicago

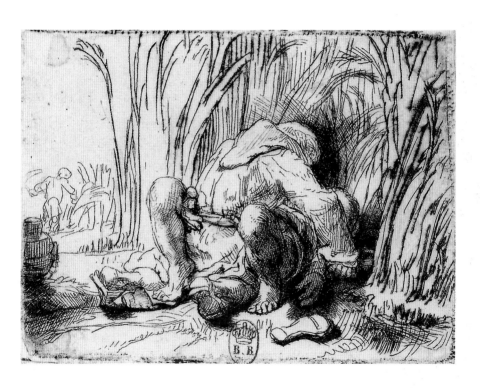

13

This much is certain: the depiction of a sexual activity alone does not qualify as erotic art, just as a shocking and pornographic object does not loose its character as art because of a context considered as indecent and immoral. To identify erotic art only with its content would reduce it to one dimension, just as it is not possible to distinguish artistic and pornographic depictions only by describing their immoral contents.

The Bed at the French Way

Rembrandt van Rijn, c. 1646
etching, 12.9 x 22.6 cm
The Pierpont Morgan Library, New York

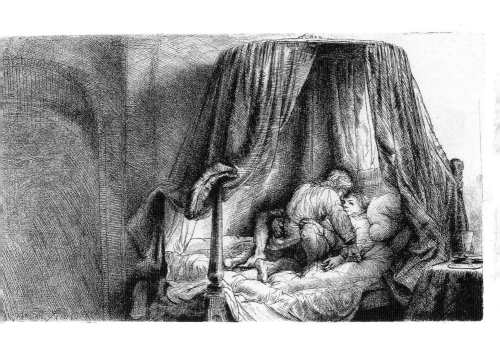

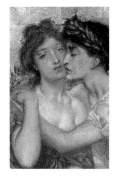

The view that erotic works are created solely for sexual arousal and so cannot be art is erroneous as well. Pornography is also a product of imagination, while its structure is different than that of sexual reality. Gunter Schmidt states that pornography is "constructed like sexual fantasy and daydreams, just as unreal, megalomaniacal, magical, illogical, and just as stereotypical".

The Rest of the Volupté

François Boucher, 1748

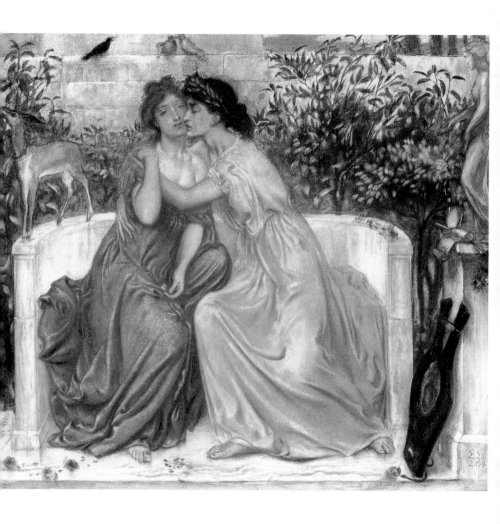

Anyhow, those proposing the alternative 'art or pornography' may have already decided against pornography, driven by their moralizing attitude.

Consequently, what is art to one person is the devil's handiwork to another. The mixing of aesthetic with ethical-moralistic questions dooms every clarification process right from the start.

Mars Embracing Venus

Jean Auguste Dominique Ingres, 1800-1806

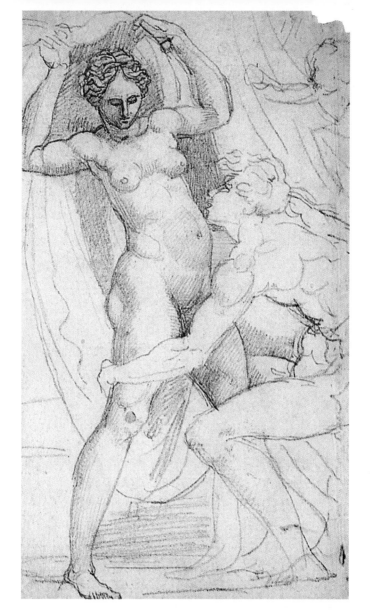

19

In its originally Greek meaning, pornography stands for prostitute writings – that is, text with sexual content. Such a definition could therefore permit us to equate the content of erotic art with that of pornography. This re-evaluation would amount to a rehabilitation of the term.

Nude Couple

Jean Auguste Dominique Ingres, 1800-1806

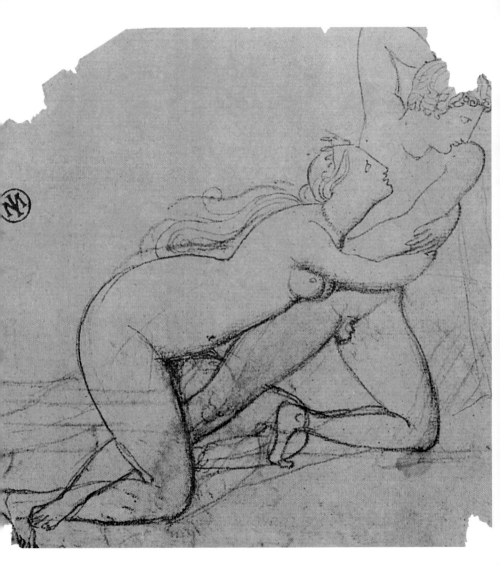

21

The extent to which the distinction between art and pornography depends on contemporary attitudes is illustrated, for example, by the painting over of Michelangelo's *Last Judgment* in the Sistine Chapel. Nudity was not considered obscene during the Renaissance. The patron of this work of art, Pope Clemens VII, saw nothing immoral in its execution. His successor, Paul IV, however, ordered an artist to cover the obscene parts of the *Last Judgment*!

Woman Caressed by Cupid

Jean Auguste Dominique Ingres, 1800-1806

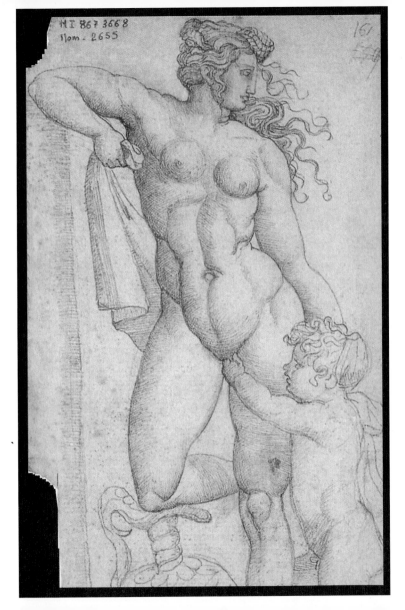

161

Not every age is equally propitious for the creation of eroticism. However, erotic art is not only a reflection of achieved sexual freedom. It can also be a by-product of the suppression and repression with which eroticism is burdened. It is even conceivable that the most passionate erotic works were created not in spite of, but rather because of the cultural pressures on sexuality.

Nude Couple Embracing on a Bed

Jean Auguste Dominique Ingres, 1800-1806

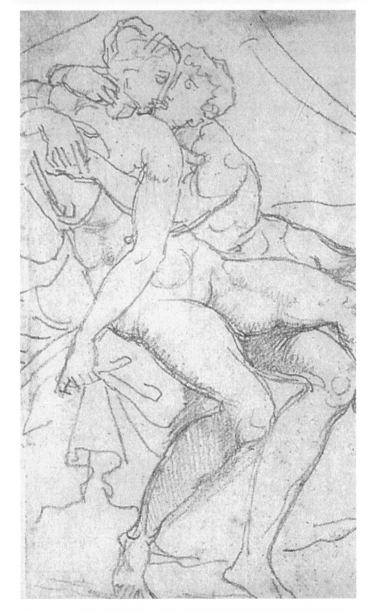

Eroticism thus would have to be understood as a socially and culturally formed phenomenon. In which case, it is the creature of moral, legal, and magical prohibitions, which arise to prevent sexuality harming the social structure. The bridled urge expresses itself; but it also encourages fantasy without exposing society to the destructive dangers of direct sexuality.

Nude Couple Making Love

Jean Auguste Dominique Ingres, 1800-1806

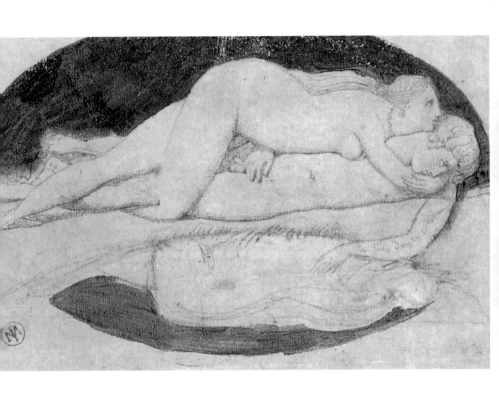

Eroticism is a successful balancing act between the rationally organized society and the demand for a licentious, destructive sexuality.

Yet, even in its tamed versions, eroticism remains a demonic power in human consciousness because it echoes the dangerous song of the sirens – trying to approach them is fatal.

Man Embracing a Woman from Behind

Jean Auguste Dominique Ingres, 1800-1806

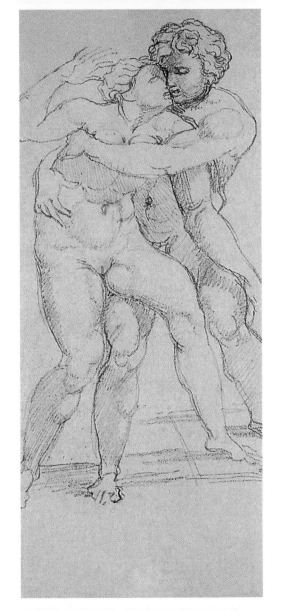

Devotion and surrender, regression and aggression: these are the powers that still tempt us. This convergence of desire and longing for death has always played an important role in literature. Insofar as eroticism consists of distance and detours, the fetishist constitutes the picture-perfect eroticist.

Nude Couple Making Love

Jean Auguste Dominique Ingres, 1800-1806

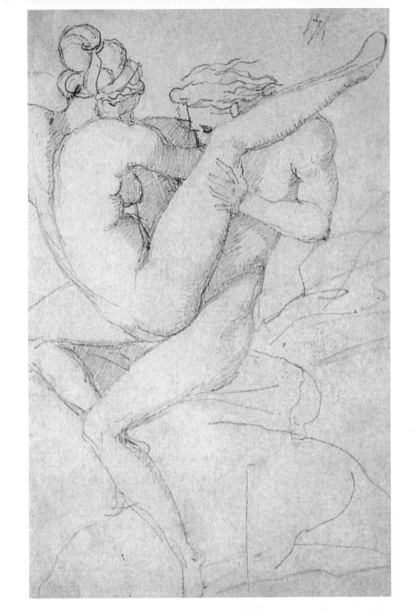

The imagined body is more meaningful than any real body. The fetishized object, in its fixed, tense relationship with what is immediate, is more significant to the fetishist than the promise of fulfilled desires represented by such an object. Collectors are eroticists as well. While the lecher or debauchee is active in real life, the fetishist lives in a realm of fantasy, where he relishes in the delights of vice even more deeply and thoroughly than the unbridled debauchee.

Seated Couple

———————

Jean Auguste Dominique Ingres, 1800-1806

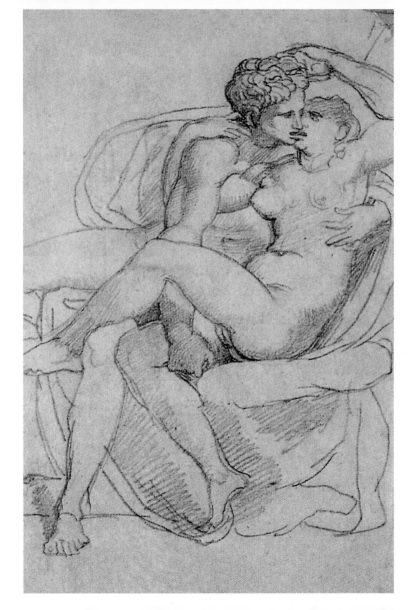

33

Distance permits freedom. Art, too – which can also represent a fetishist production for the artist – affords freedom. It affords the freedom to play with fire without being burned. It appeals to the eye; it allows toying with sin without having sinned. Art would have the power to reduce the immediate force of sensuality.

Three Women in Bath

Jean Auguste Dominique Ingres, 1800-1806

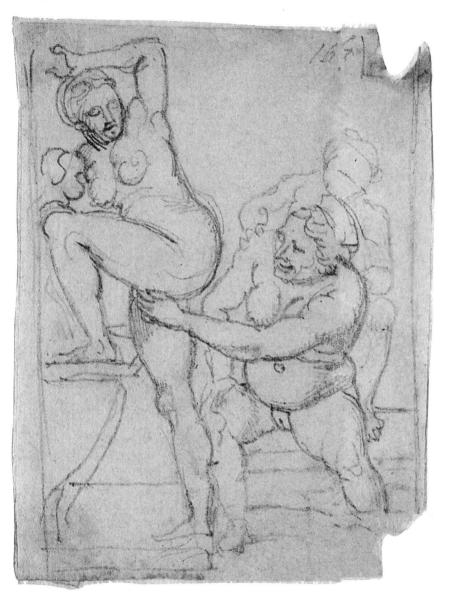

35

Eduard Fuchs, the past master of erotic art, whose books were accused of being pornographic during his lifetime, considers eroticism to be art's fundamental subject: sensuality is said to be present in any art. Accordingly, it would almost be a tautology to speak of erotic art.

Union (Mars and Venus?)

Jean Auguste Dominique Ingres, drawing, 1800-1806

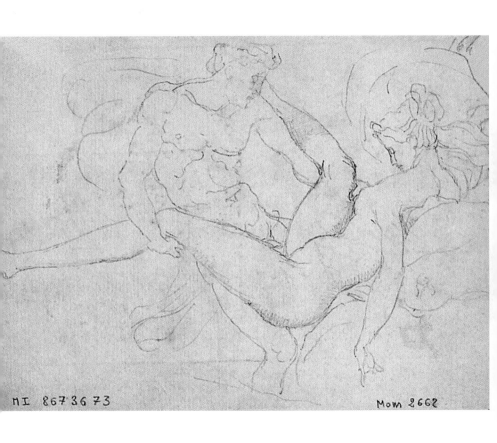

Long before Fuchs, Lou Andreas-Salomé had already pointed out the true relationship between eroticism and aesthetics: "It seems to be a sibling growth from the same root that artistic drive and sexual drive yield such extensive analogies, aesthetic delight changes into erotic delight so imperceptibly, sexual desire so instinctively reaches for the aesthetic, the ornamental".

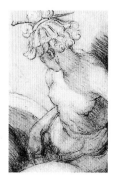

A Man with Three Women

Johann Heinrich Füssli (Henry Fuseli), c. 1809-1810
pencil and wash drawing on paper, 18.9 x 24.5 cm
Victoria and Albert Museum, London

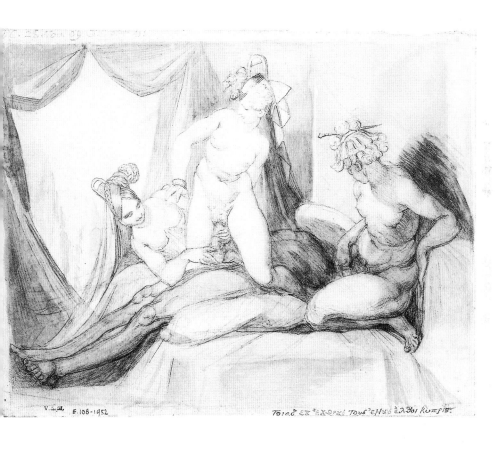

Τοιαδ επ εχθροις τους εμης ελθοι κυπρις

Once, when Picasso, at the eve of his life, was asked about the difference between art and eroticism, his pensive answer was: "But there is no difference."

Instead, as others warned against eroticism, Picasso warned against the experience of art:

The Union

Théodore Géricault, c. 1817
graphite, pen, brown ink
and white gouache on blue paper
13.5 x 21.3 cm
Musée du Louvre, Paris

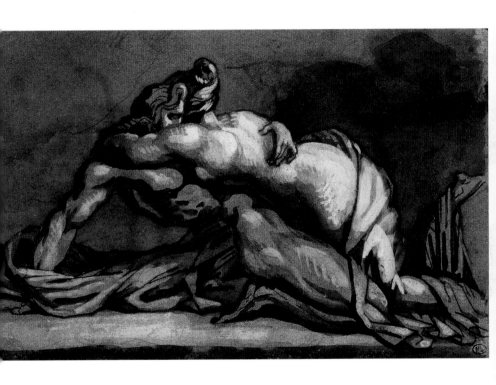

41

"Art is never chaste, one should keep it away from all innocent ignoramuses. People insufficiently prepared for art, should never be allowed close to it. Yes, art is dangerous. If it is chaste, it is not art." Seen with the eyes of a moral watchdog, every type of art and literature would have to be abolished.

Sapphic Couple Lying
near a Wheel of Fortune

Auguste Rodin, 19th-20th century
graphite and watercolour on paper, 25 x 31 cm
Musée Rodin, Paris

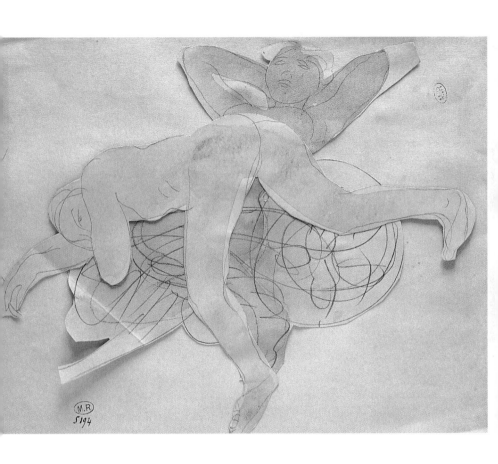

M.R
5194

43

If spirituality is the essence of humanity, then all those opposing mind and spirit to sensuality are hypocrites. Sexuality experiences its true spiritual form, its true humanity, only after developing into eroticism and art – some translate eroticism as the art of love.

Temple of Love

Auguste Rodin, 19th-20th century
graphite and watercolour on paper, 25 x 32.6 cm
Musée Rodin, Paris

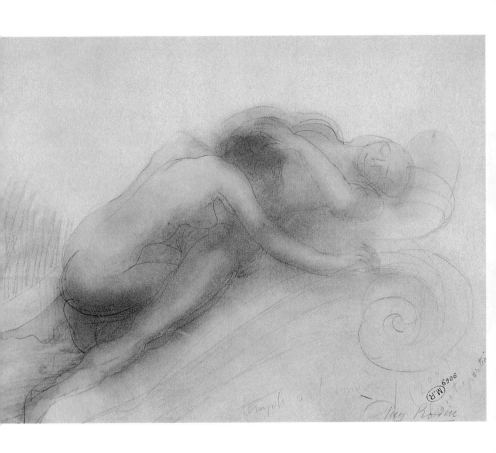

Matters excluded from the civilizing process assert themselves by demanding a medium that is spiritually determined, and that is art.

"Pornography" is a judgmental term used by those who remain closed to eroticism. It is assumed that their sensuality never had the opportunity to be cultivated.

Salambô

Auguste Rodin, 19th-20th century
graphite and stamp on paper, 25 x 32.6 cm
Musée Rodin, Paris

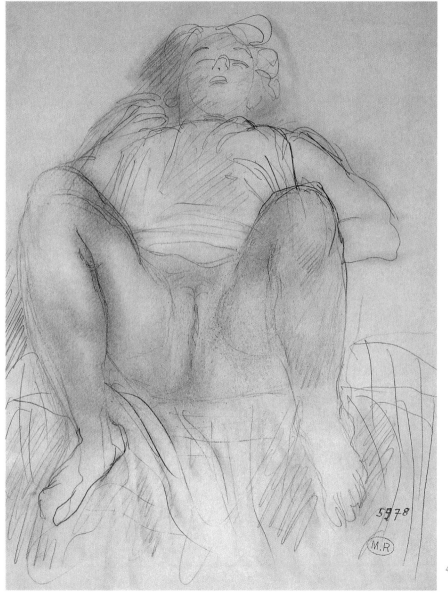

5978

M.R

47

Even the observation that a work has offended or violated the viewpoints of many still does not make it pornographic. Works of art can offend and injure the feelings of others; they do not always make viewers happy. After all, is it not the duty of art to annoy and to stir things up?

Seated Woman

Auguste Rodin
lead, watercolour and stamp on paper

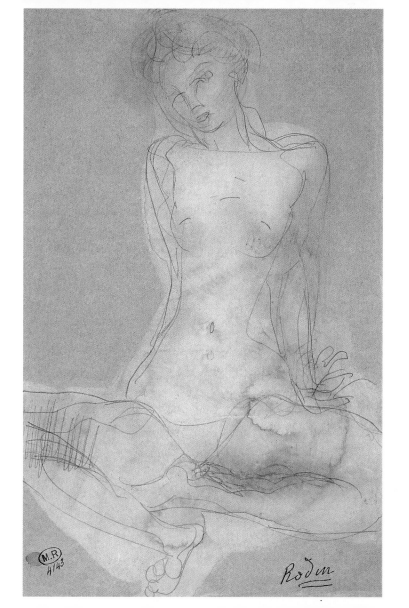

M.R
4143

Rodin

49

The term pornography is thus no longer in keeping with the times. Artistic depictions of sexual activities, whether they annoy or please, are part of erotic art. If not, they are insipid, dumb works, even if harmless.

All artists – painters, sculptors of all periods – were able to reproduce erotic designs.

Sapphic Couple Seated

Auguste Rodin, 19th-20th century
graphite, stamp and watercolour
32.6 x 25.2 cm
Musée Rodin, Paris

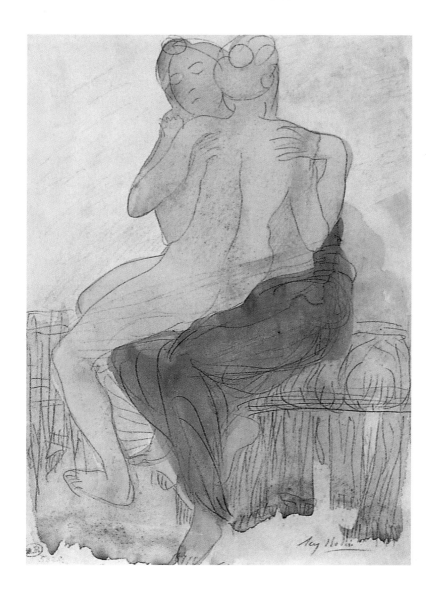

51

Michelangelo, Rembrandt, Rubens, Boucher, Fragonard, Ingres, Géricault, Degas, Rodin, Rops, Klimt, Schiele, Picasso, Pascin are artists celebrated for their erotic works. Their erotic designs are captivating, without being repetitive. Each one is unique, as the diverse design techniques permit a different rendering.

Female Nude with Long Hair
Leaning backward

Auguste Rodin, 19th-20th century
graphite and watercolour on paper, 27.5 x 21.4 cm
Musée Rodin, Paris

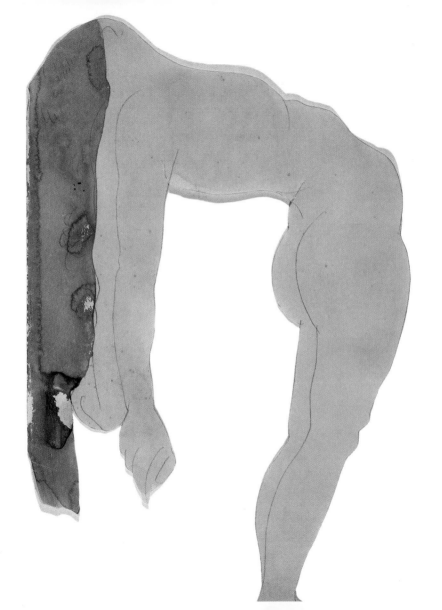

These techniques (pencil, charcoal, white chalk on colored paper, graphite, aquarelle and mixed techniques) permit a vivid design which invites us to contemplate on these erotic scenes. The scenes presented by the artists are sometimes treated in a saucy, humorous tone, whereas sometimes they can be quite crude and prosaic.

In the Salon

Edgar Degas, c. 1876-1877
monotype, 15.9 x 21.6 cm

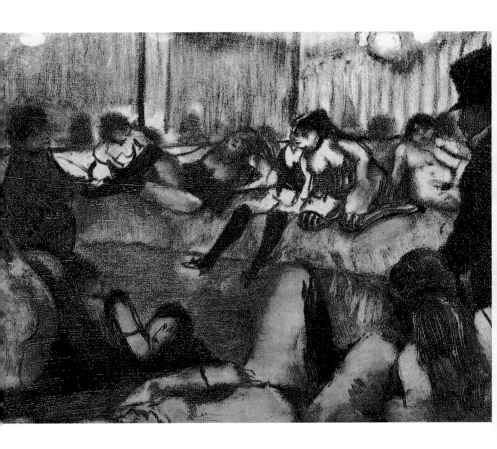

Some of these designs were the preparatory studies for painted works. These erotic designs differ from "traditional" nude studies in the degree where the erotically charged atmosphere is transmitted by the design's particular technique.

The Procures

Edgar Degas, c. 1876-1877
monotype, 16.5 x 11.8 cm
Bibliothèque d'Art et d'Archéologie, Paris
(Foundation Jacques Doucet)

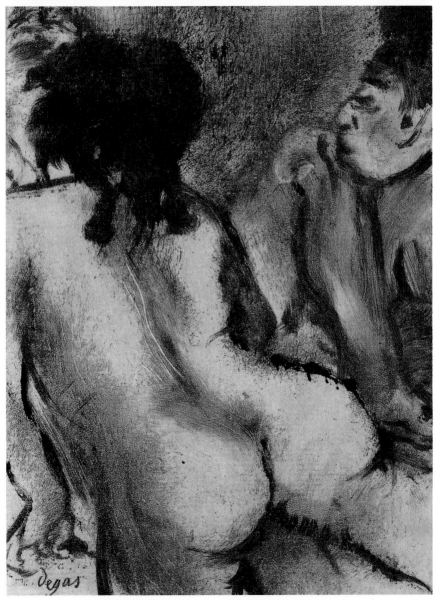

The Artists
Michelangelo (1475-1564)

The erotic drawing would occupy a very important place in the work of Michelangelo and thus he is considered to be the epitome of the idea... In his first drawings net contours isolate the body whilst vigorous hatching underlines the movement. The artist prefers colouring effects which would blend the body into the surrounding background allowing the viewer to emerge themselves into the painting.

Two Women (Scene in a Brothel)

Edgar Degas, c. 1876-1877 or 1879-1880
monotype
Katherine Bullard Fund
Museum of Fine Arts, Boston

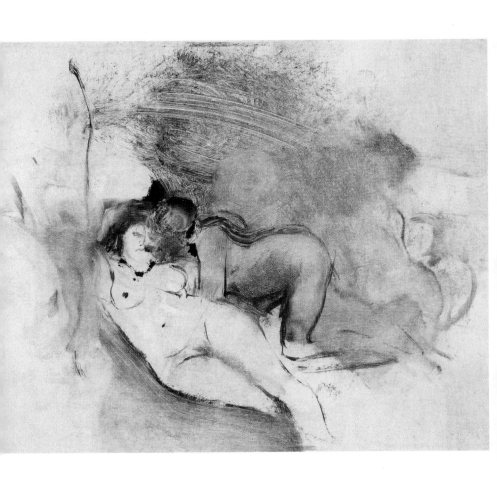

Rembrandt van Rijn (1606-1669)

Rembrandt was not only a great painter but also had an excellent talent for drawing and engraving. He was born in Holland. Rembrandt is characteristic in his passion for the expression of human emotion and psychology, (especially his own) and translated these elements into art in a realist fashion employing a technical virtuosity.

Madame's Name-Day

Edgar Degas, c. 1876-1877
monotype, 11.5 x 15.9 cm

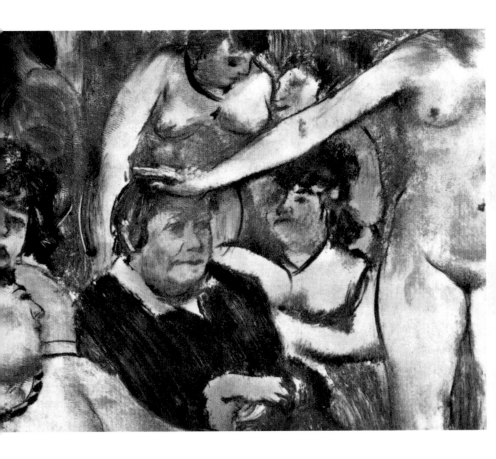

François Boucher (1703-1770)

The feminine nude, of whom he had a particularly sensual conception was Boucher's preferred subject to such an extent that even his mythological allegories or his scenes of "sheepfolds" were only considered as pretexts for debauchery.

Admiration

Edgar Degas, 1876-1877
black ink monotype, with red and black
pastel highlights on paper, 21.5 x 16 cm
Bibliothèque d'Art et d'Archéologie, Paris

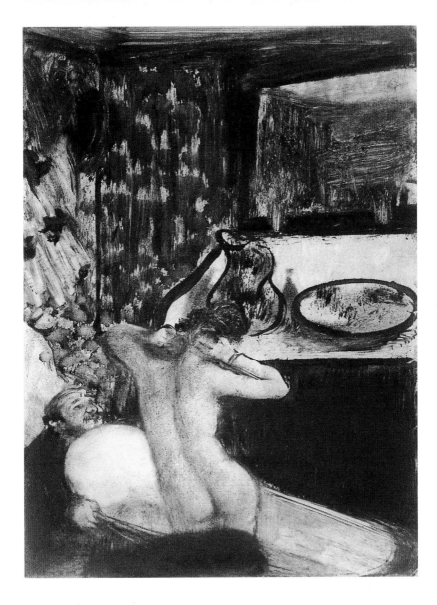

63

His series of etchings (which feature some drawings for works by Molière) as well as his drawings, evoke paintings from Watteau's genre, not only through their fluidity of line but also by their grace and elegance.

"Haisne et Amour de prestre
sont de mesme Viol"
Courtesy Derom Gallery, Brussels

Felicien Rops, c. 1878
charcoal, Indian ink wash and pastel, 22 x 28.5 cm
Courtesy of Derom Gallery, Brussels

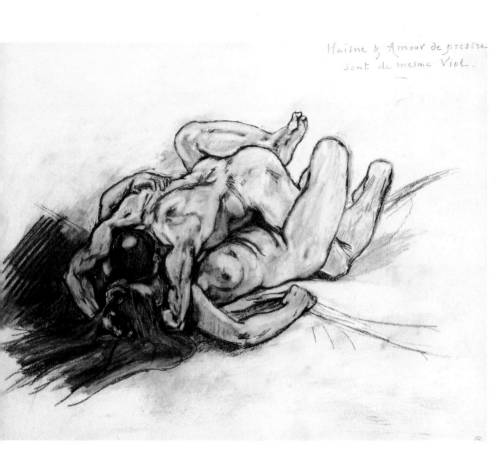

Haisne & Amour de prestre
sont de mesme Viol.

Johann Heinrich Füssli (1741-1825)

His feather ink drawings are quite unique. The nervous drawing technique imparts to the powerful, sculpted figures and the violence and the vigour of the movement. His drawings which feature women, magicians or sophisticated actresses don't hesitate in evoking erotic desires in their viewers.

Impudence

Felicien Rops, c. 1878
colouring pencil, 18 x 12 cm
Royal Mariemont Museum, Morlanwelz

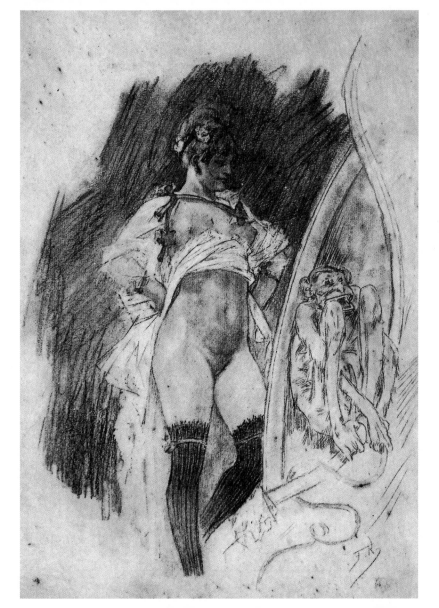

Jean-Auguste Dominique Ingres (1780-1867)

Ingres distinguishes himself from his artistic peers by the precision and the purity of his drawing technique. The nudes (of which many were couples) constitute the more original part of his work. His sensual celebration of feminine beauty is strengthened by the great refinement of the contours of the body.

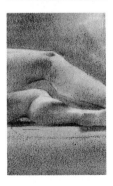

Dinner for Atheists

Felicien Rops, 1879, from *Les Diaboliques*
pencil, 24.4 x 18.5 cm
Brussels

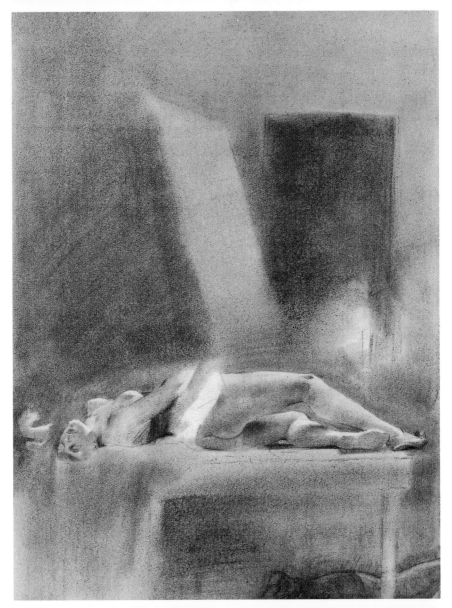

Théodore Géricault (1791-1824)

It is especially through his drawings that Géricault demonstrates his inventiveness and expressive power. He is audacious in his choice of themes as he is in his use of diverse techniques. The artist freely creates his erotic scenes with a firm candour often through his studies of antique mythology.

The Tub

———

Edgar Degas, c. 1880
monotype

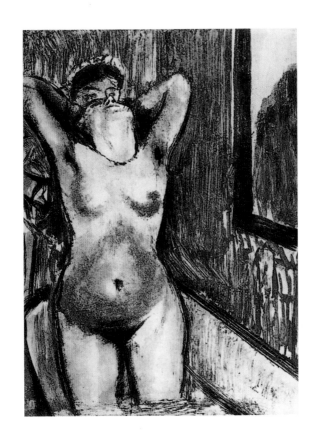

Félicien Rops (1833-1898)

Rops began his career as a cartoonist but soon became the master of representing both the woman and desire. His drawings underline the provocative and erotic role of representation by applying smooth tones or light effects. His work covers the whole scale of eroticism, from debauchery to pornography, all in conserving a certain artistic delicacy.

The Morning Bath (The Baker's Wife)

Edgar Degas, c. 1885-1886
pastel on paper, 67 x 52 cm
Henry and Rose Pearlman Foundation

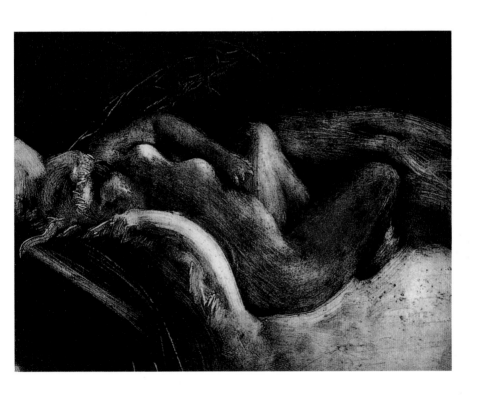

Edgar Degas (1834-1917)

Degas belongs to the Impressionist group. However, contrary to them, he has produced a large quantity of pastel works and monotypes. From the moment that Degas achieves artistic maturity in the 1870s all his representations of women are tinged by an atmosphere of debauchery.

Embracing Couple,
from the *Circle of Loves*

Auguste Rodin, c. 1889
graphite, pen and ink on paper, 16.2 x 10.2 cm
Musée Rodin, Paris

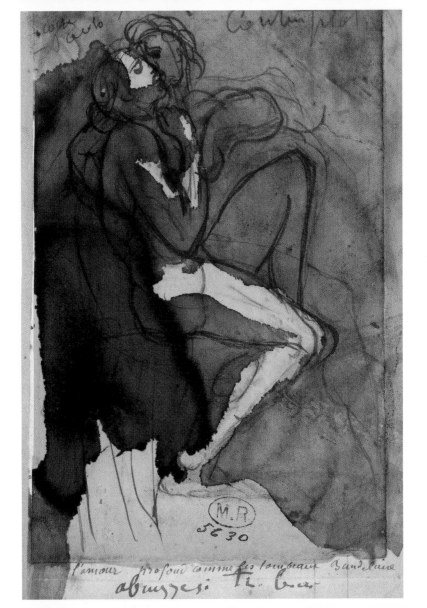

75

His quick drawings show that he is interested by line and is precise in his depiction of movement. Degas represents (in his drawings) the sinister and modern world of prostitution. These drawings feature women in provocative poses but who are, nevertheless, sensual. They are selling their bodies to men in top hats who are in search of pleasure.

Behind the Scenes
Felicien Rops, c. 1879-1881
coloured pencils, pastel and watercolour
22 x 14.5 cm
Private collection, Brussels

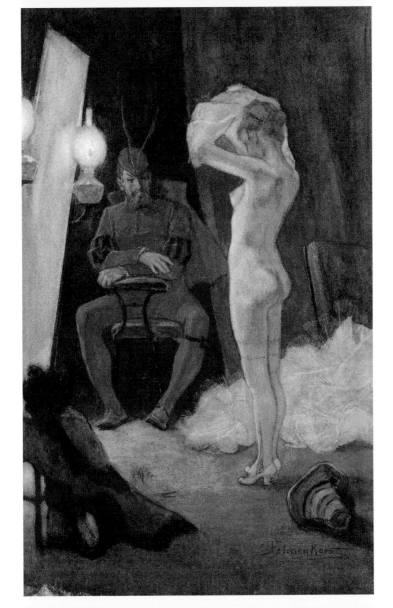

Auguste Rodin (1840-1917)

In his drawings Rodin attempts to capture the fugitive attitudes of his models as well as their movement, attitudes and gestures. His attraction to eroticism and sensual delight is particularly evident in his drawings which reveal an exuberant world of uninhibited pleasures.

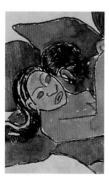

Ancient Maori Cult

Paul Gauguin, c. 1893
pencil, ink and watercolour on paper
21.7 x 16.9 cm
Musée du Louvre, Paris

de leurs trompettes et à battre de leurs
tambours, ce qui était le signal de la
retraite et de la fin de la fête. Le roi
retournait alors à sa demeure, accompagné
de sa suite.

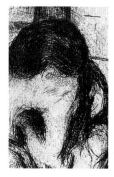

No pose is too daring and the physical details are sensual and indeed openly sexual. Rodin had drawn all his life but the drawings he made from around the turn of the century (when he was sixty) to his death in 1917 are utterly distinctive. There are around 8,000 of them.

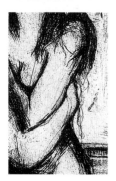

The Kiss

———

Edvard Munch, 1895
etching, 32.9 x 26.3 cm
Munch-Museet, Oslo

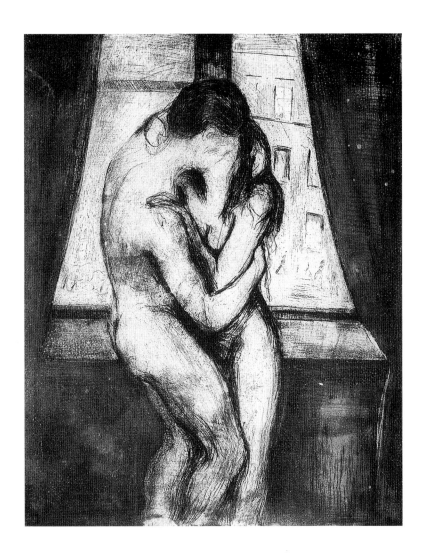

Made either with pencil alone, or with the addition of pen and ink or colour washes, these late drawings are images of the most refined simplicity and concise beauty. They divide into two types: female dancers, in particular Javanese and Cambodian dancers, and nude female models.

Lysistrata Defending the Acropolis
―――――――――――――――――――――

Aubrey Beardsley, 1896
illustration for *Lysistrata* by Aristophanes
pen and ink

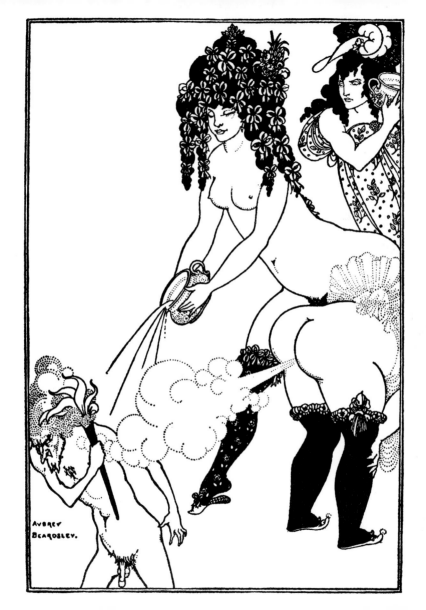

AVBREY
BEARDSLEY.

Both types were made very quickly, in pencil, from life; some were worked up later. A few were made by tracing from the original onto another sheet – so as to eliminate superfluous lines as a further means of simplification; some were cut-out and recombined with other figures. This method of working was highly unusual – both for its speed and freedom.

Lacedemonian Ambassadors

Aubrey Beardsley, 1896
illustration for *Lysistrata* by Aristophanes
pen and ink

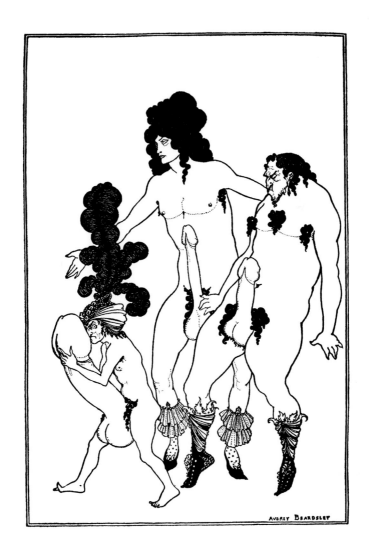

Rodin did not look at the page while he was working. Neither did he ask his models to hold any particular pose. Instead he drew as they moved freely around him, letting each finished sheet fall to the floor as he began another. The daring poses and viewpoints and the bold distortions that resulted are extraordinary.

Cinesias Entreating Myrrhina to Coition

Aubrey Beardsley, 1896
illustration for *Lysistrata* by Aristophanes
pen and ink

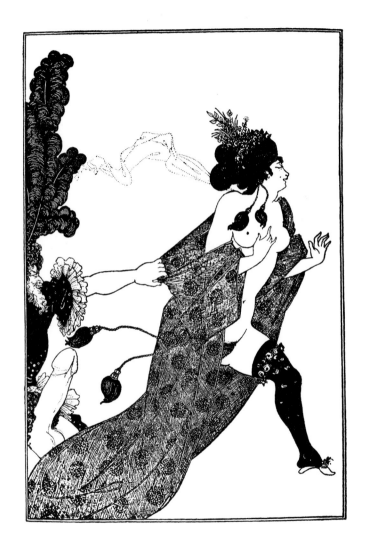

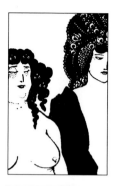

This very innovative way of working coincided with Rodin's obsession with modern dance during this late period. Writing in an article published in 1912 he claimed that dance has always had the prerogative of eroticism in our society. In this, as in other expressions of the modern spirit, women are responsible for the renewal.

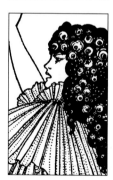

Lysistrata Haranguing the Athenian Women

Aubrey Beardsley, 1896
illustration for *Lysistrata* by Aristophanes
pen and ink

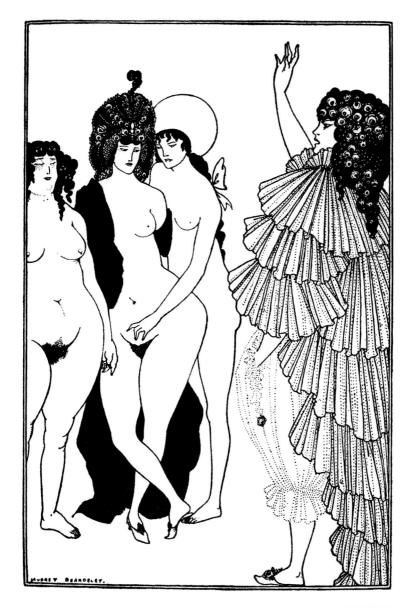

Isadora Duncan, another American dancer called Loie Fuller, Diaghilev, Nijinsky, the Japanese actress Hanako all knew him and posed for him. Isadora Duncan opened a ballet school and brought her students to Rodin's studio so that he could draw them.

The Examination of the Herald

Aubrey Beardsley, 1896
illustration for *Lysistrata* by Aristophanes
pen and ink

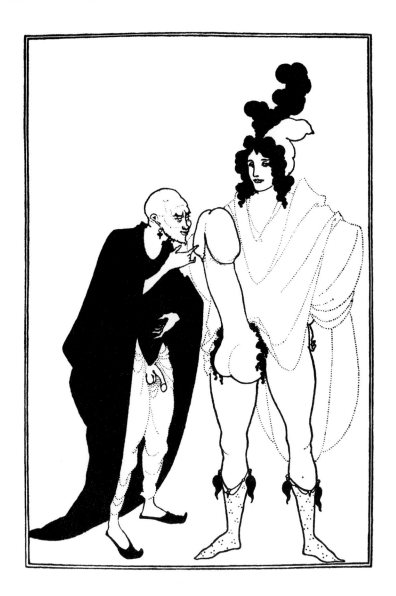

In 1906 Rodin followed a group of Cambodian dancers from Paris to Marseilles for the same purpose. His ecstatic response to these various dancers' elegant and liberated movement found expression in sculptural form (Iris) as well as drawings.

Lysistrata Shielding Her Coynte
———————————————————————
Aubrey Beardsley, 1896
illustration for *Lysistrata* by Aristophanes
pen and ink
Victoria and Albert Museum
Harari Collection, London

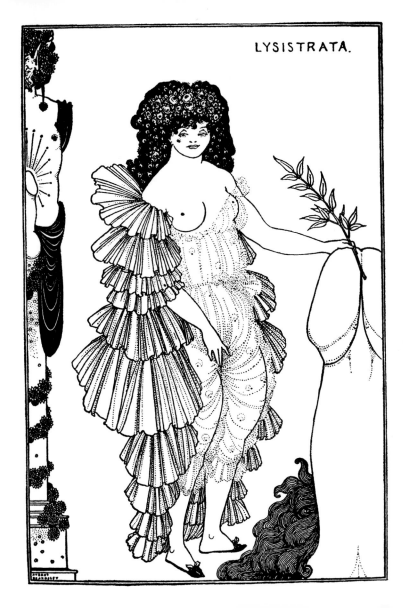

LYSISTRATA.

When dancers were not available to draw from Rodin was wealthy enough to employ models. Many of these drawings of nude models are of an intensely erotic nature; the ones illustrated here are among them. They are unlike anything else by his hand.

The Penis Measures

Aubrey Beardsley, 1896
illustration for *Lysistrata* by Aristophanes
pen and ink

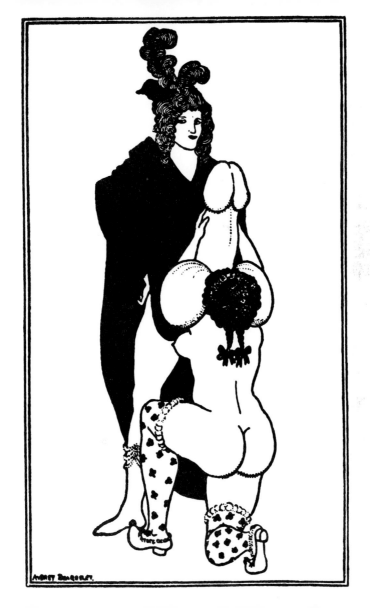

AUBREY BEARDSLEY.

Rodin had produced erotic drawings at other times and under different circumstances – for book illustrations. He had provided drawings for a privately printed edition of Baudelaire's Les Fleurs du Mal (1885) and for a limited folio edition of Octave Mirbeau s Le Jardin des supplices (1902);

Two Athenian Women in Distress

Aubrey Beardsley, 1896
illustration for *Lysistrata* by Aristophanes
pen and ink

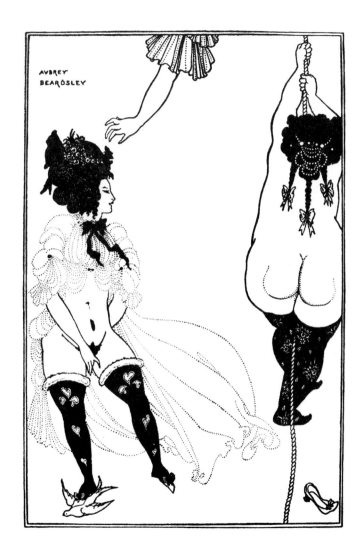

AVBREY
BEARÖSLEY

97

but neither of these even palely matches the later drawings for obsessive, sexual concentration, energy and freedom. The works by Rodin reproduced in lithograph for Mirbeau's erotic novel do not focus on female pudenda as do the later ones, although they are similar in style.

The Impatient Adulterer

Aubrey Beardsley, 1896
illustration for the *Satires* by Juvenal
pen and ink
Victoria and Albert Museum
Harari Collection, London

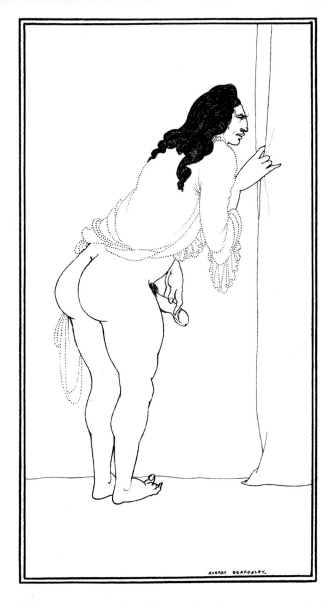

AUBREY BEARDSLEY.

The Baudelaire drawings are also far less explicit and were made in a darker, nervous and more agitated graphic style. Certainly the troubled, painful character of these drawings as well as the sculptures made at around the same time are comparable in mood to the tone and atmosphere both of Baudelaire's poetry and The Gates of Hell.

Toilet of Lampito

Aubrey Beardsley, 1896
illustration for *Lysistrata* by Aristophanes
pen and ink
Victoria and Albert Museum
Harari Collection, London

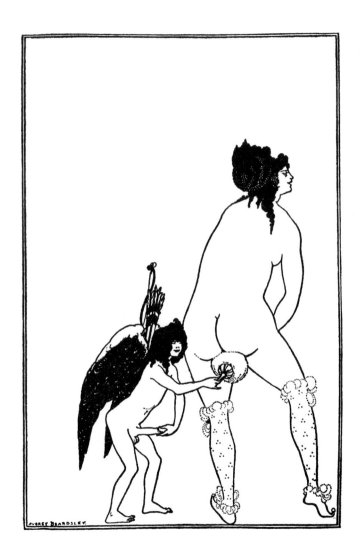

It seems reasonable to sense in works such as Je Suis Belle (the title is taken from a poem by Baudelaire; both figures may be also found, separately, on The Gates) for example, a guilty or morbid erotic vision in which sexual fulfilment remains unattainable.

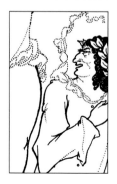

Juvenal Scourging Woman

Aubrey Beardsley, 1897
illustration for the *Satires* by Juvenal
pen and ink

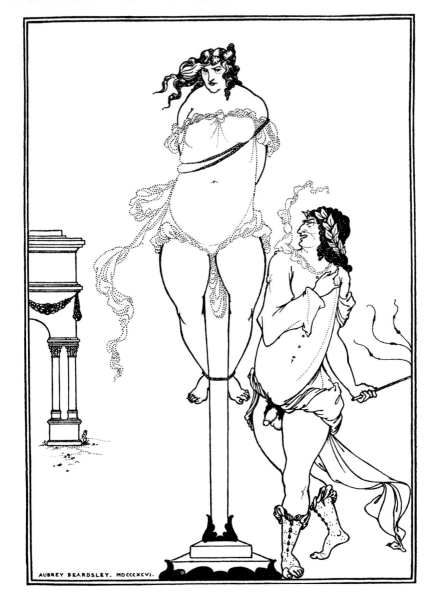

AUBREY BEARDSLEY. MDCCCXCVI.

103

The later drawings display nothing of the self-conscious and virtuosic indulgence in such an oppressive expression of darkness, struggle and godlessness. They are of a different order altogether. Principally what distinguishes them is their quantity (generally unknown until quite recently);

Bathyllus Posturing
———————————

Aubrey Beardsley, 1897
illustration for the *Satires* by Juvenal
pen and ink
Victoria and Albert Museum, London

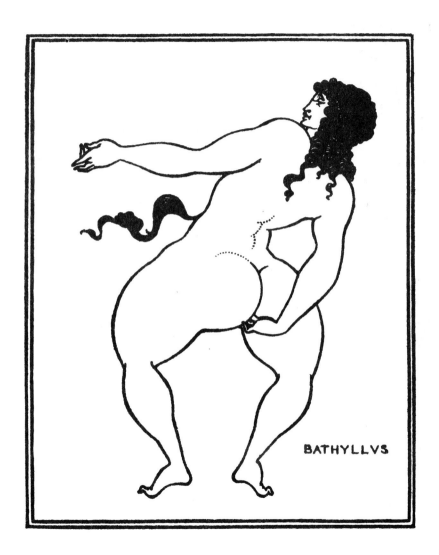

BATHYLLVS

105

the fact that the vast majority were never exhibited; the innovative methods by which they were made and the uncompromising, obsessive nature of their subject-matter. Nude, female models are drawn, time after time after time, with legs spread apart.

Garden of Tortures

Auguste Rodin, c. 1898
graphite, stamp and watercolour on paper
32.5 x 25 cm
Musée Rodin, Paris

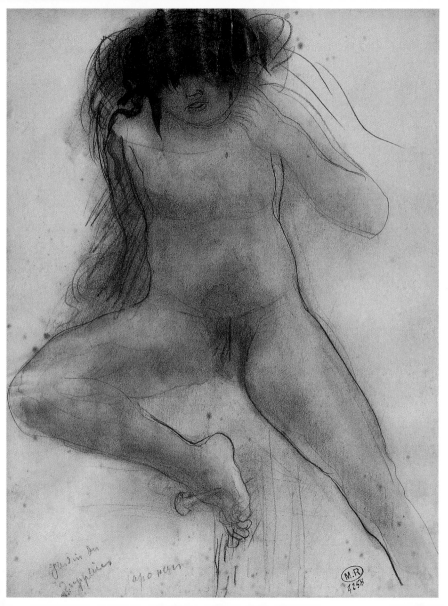

Jardin des
nymphées
Japonais

M.R
4258

107

The vulva is placed at the centre of the image – this is the fulcrum or focus, as it were, of Rodin's old age. In some, the models masturbate and either mimic or perform acts of lesbian love. Categorically it seems that Rodin had left behind the guilt and torment of The Gates to enter a labial world of uninhibited exuberance and pleasure.

Burning Bush

Auguste Rodin
pencil and watercolour on paper
32.7 x 35 cm
Musée Rodin, Paris

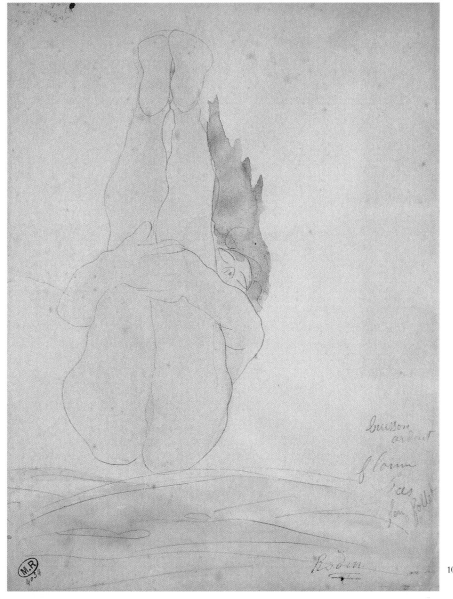

109

Paul Gauguin (1848-1903)

Gauguin wants his drawings to translate his love for the visible beauty and sensuality of the world. The stark lines, the freedom and the fluidity of the shapes introduce energy, emotion and life into his drawings. Gauguin loves to draw all that is real, simple, concrete and human.

Two Lovers

Gustav Klimt, 1901-1902
sketch for the *Beethoven Frieze*
black pencil, 45 x 30.8 cm
Vienna

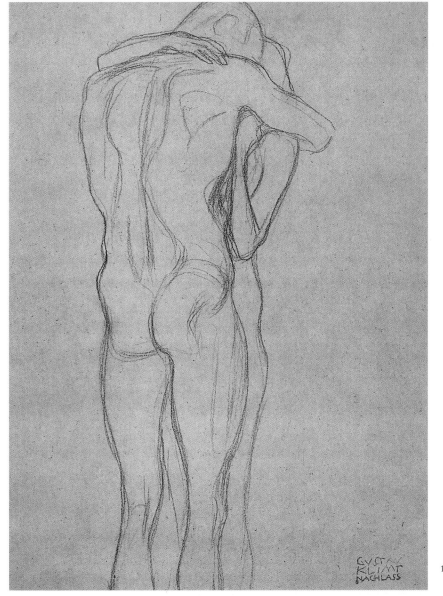

GVSTAV
KLIMT
NACHLASS

111

Gustav Klimt (1862-1918)

Klimt said 'All art is erotic'. This approach is very apparent in his work, all the more so than the raw sensual beauty of the woman. He produced numerous scenes of naked women or languorous and erotic poses in glistening, sensual and luxurious surroundings.

Two Friends

Felicien Rops, c. 1888-1890
Watercolour, 30.5 x 21 cm
Felicien Rops Museum, Namur, Belgium

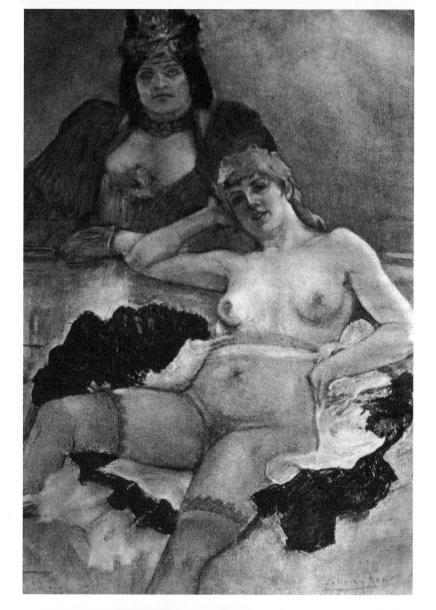

In his studio Klimt kept girls available to him at all times, waiting for him in a room next door in case he decided to paint them. Franz Servaes, a contemporary art critic, observed: Here he was surrounded by mysterious, naked female creatures, who, while he stood silent in front of his easel, strolled around his studio,

Girlfriends

1905
black chalk, 45 x 31 cm
Historisches Museum, Vienna

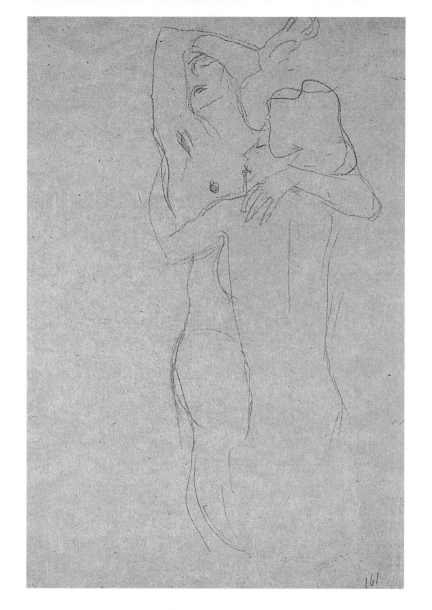

161

stretching themselves, lazing around and enjoying the day – always ready for the command of the master obediently to stand still whenever he caught sight of a pose or a movement that appealed to his sense of beauty and that he would then capture on a rapid drawing.

Girlfriends Embracing

Gustav Klimt, 1905
graphite, 38 x 57 cm
Historisches Museum, Vienna

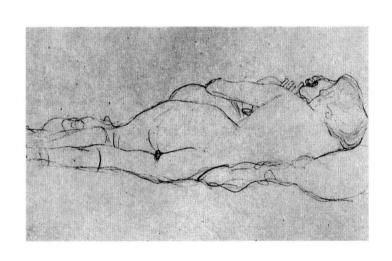

Klimt made sketches for virtually everything he did. Sometimes there were over a hundred drawings for one painting, each showing a different detail – a piece of clothing or jewellery, or a simple gesture. Unfortunately, the bulk of his sketchbooks were destroyed not by cats but by a fire in Emilie Flöge's apartment. Only three of the books survived.

The Garden of Aphrodite

Franz von Bayros, 1907
from *Drawings of Love*

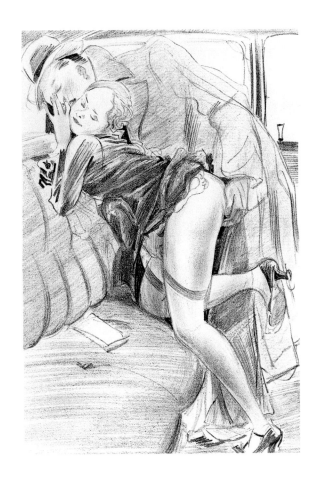

The drawings which have survived, however, provide a fascinating insight into Klimt's artistic and personal preoccupations: whereas in his paintings nudity and sexuality are covered, almost imprisoned by ornament and textile to be partially and tantalisingly revealed, in his drawings eroticism is open and undisguised.

Two Women Embracing

Auguste Rodin
lead and watercolour on paper

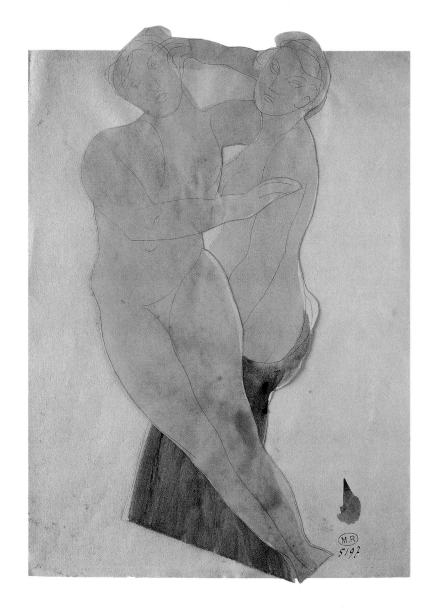

Even during his lifetime his drawings were regarded by some critics as the best work of his entire oeuvre, but they would not have been widely seen. Unlike Schiele, who earned his living from his drawings, Klimt's income was derived entirely from his painting. Drawing for him was either a necessary preparatory process or a form of relaxation, a way of expressing himself spontaneously free from the constraints and detail of oil.

Female Nude

Egon Schiele, 1910
black chalk, watercolour,
gouache and white highlights, 44.3 x 30.6 cm
Graphische Sammlung Albertina, Vienna

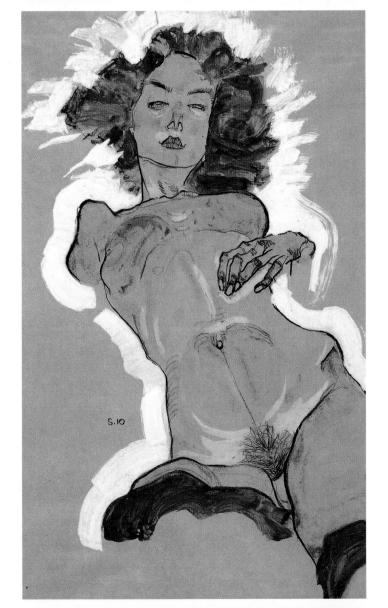

S.10

Klimt's drawings not only reveal his mastery of draughtsmanship, they also show an erotic obsession and a sexual freedom quite at odds with the covered-up, repressed society in which he moved. In these drawings there is no visual, temporal, or spacial context, just the women themselves, who were presumably, as earlier described, wandering around his studio in a state of undress.

One Contemplated in Dreams

Egon Schiele, 1911
graphite and watercolour on paper, 48 x 32 cm
The Metropolitan Museum of Art, New York

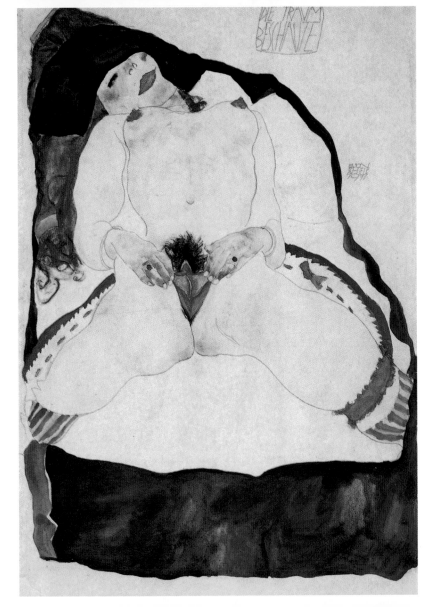

125

He draws them only in outline, omitting any internal modelling or shading of their bodies and almost always drawing attention to their genitalia or breasts by using perspective, foreshortening, distortion or other formal techniques. A wonderful example of how a couple of pencil strokes can be used to devastatingly erotic effect is in the 1905-6 drawing Friends Embracing,

The Red Communion Wafer

Egon Schiele, 1911
graphite and watercolour on paper, 48.2 x 28.2 cm
private collection, courtesy St Etienne Gallery, New York

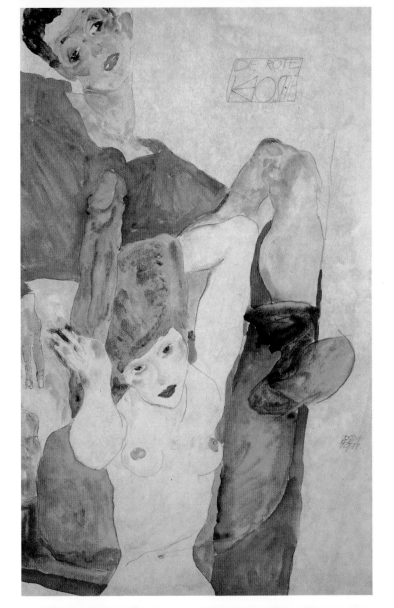

in which a tiny circle of darkness draws the viewer s gaze automatically between the woman's legs and her buttocks. The women are frequently depicted asturbating, absorbed in their own sensual pleasures, eyes closed, face slightly averted. How very at ease these women must have felt with Klimt to allow him to portray them in this way!

Seated Nude Girl
with Arms Raised over Head

Egon Schiele, 1911
graphite and watercolour on paper
48.2 x 31.4 cm
private collection

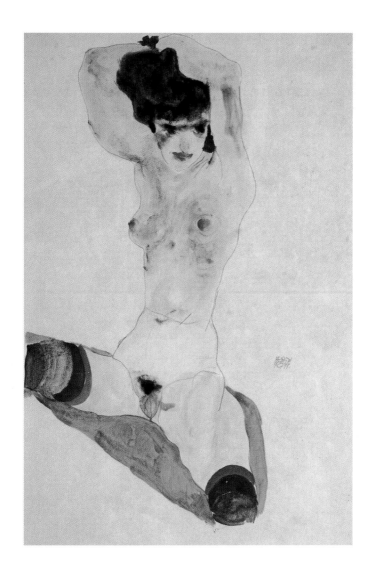

Langorous, feline, and utterly absorbed, they masturbate delicately, fingers poised above the clitoris, still fully or partially clothed, eyes closed in the imaginary heat of a summer's afternoon. Sometimes Klimt draws in great detail; sometimes it is the overall pose that clearly interests him.

Reclining Semi-Nude
———————————

Egon Schiele, 1911
graphite, watercolour and gouache on paper
47.9 x 31.4 cm
private collection

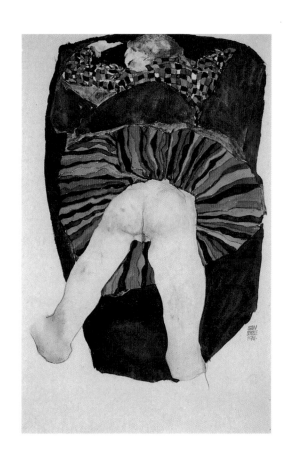

131

Men rarely make an appearance in these drawings, and when they do they are almost uniquely depicted with their back to the viewer. In general, apart from academic studies at art school, men in Klimt's paintings are peripheral figures.

The Lovers VI

Ernst Ludwig Kirchner, 1911
lithograph, 16.8 x 21.9 cm
Hauswedell & Nolte, Hamburg

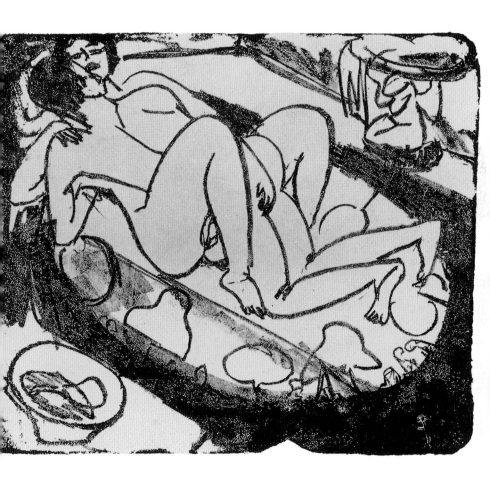

133

Their faces are rarely shown, and they seem to exist either as voyeurs or simply as the physical partner to a sexual act of which the woman is the main point of interest for the viewer. What is extraordinary in Klimt s work is that, while expressing his clear admiration for women's beauty, when he shows men and women together he articulates a kind of emoteness, a gulf between the sexes.

Nude Lying down and Huddling

Gustav Klimt, 1912-1913
graphite, red, blue and white pencil, 37 x 55.8 cm

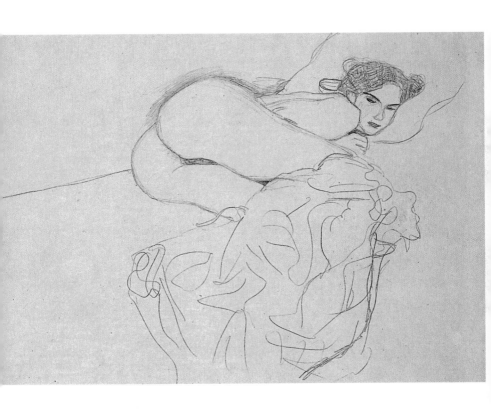

Edvard Munch (1863-1944)

Munchs' drawings are in the same way as the rest of his works represenive of his own particular world. Although they give the impression of a certain spontaneity the artist searches to represent feelings, love and suffering.

Wally in Red Blouse with Raised Knees

Egon Schiele, 1913
gouache, graphite and watercolour, 31.8 x 48 cm
private collection

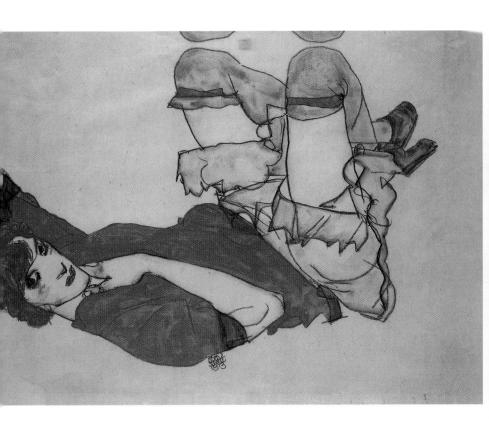

137

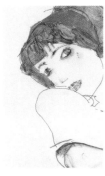

Aubrey Beardsley (1872-1898)

An English illustrator who illustrates notably erotic comedies. He achieves a perfect sense of composition, a remarkable use of space, a nervous outlining as well as an imagination mixing eroticism, cruelty and irony.

Woman with Black Stockings
(Valerie Neuzil)

———————

Egon Schiele, 1913
graphite, watercolour and gouache on paper, 32.2 x 48 cm
private collection, courtesy St Etienne Gallery, New York

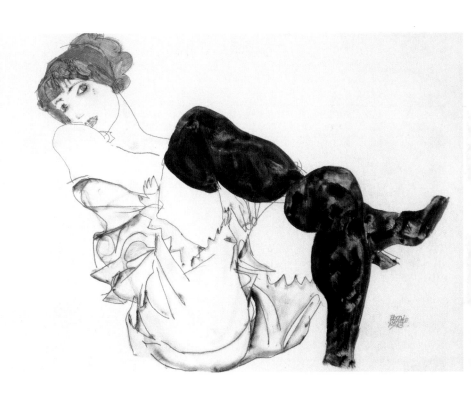

Ernst Ludwig Kirchner (1880-1938)

A large number of Kirchners' works are violently expressive, not only in terms of the choice of subjects but also in the style which is characterised by an indecisive drawing technique. His erotic graphic activity is intense and varied, and is demonstrated just as well in his drawings of young naked models indoors as in those outdoors.

Woman with Black Stockings

Egon Schiele, 1913
graphite, watercolour and gouache on paper, 48.3 x 31.8 cm
private collection, courtesy St Etienne Gallery, New York

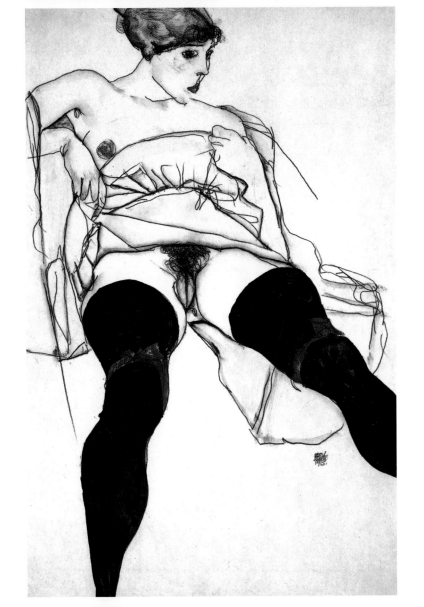

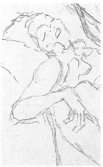

Pablo Picasso (1881-1973)

Picasso, for whom each creation proceeded a sexual desire produced a whole series of erotic drawings. According to the period of his life, Picasso would reveal his moving vision of the woman, of tumultuous love or even an unbridled voyeurism. Each body would announce a new artistic approach. The liberty of expression would combine desire, fascination, virility, fertility and sensuality.

Two Female Nudes Lying down

Gustav Klimt, 1914-1915
graphite, 54 x 35.3 cm
The Metropolitan Museum of Art, New York

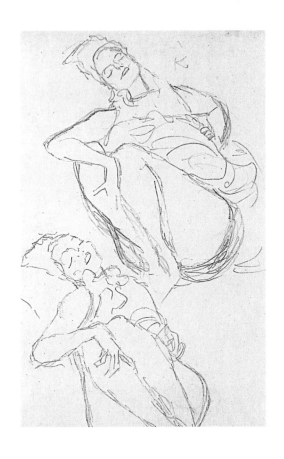

143

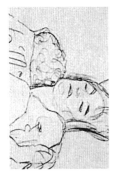

Jules Pascin (1885-1930)

Very soon familiar with the brothels, Pascin would find, throughout his career his models of predilection appreciating their immediate sensuality and their passiveness. Thus the artist would excel during the whole of his career in the representation of nudity in which one mixes truth of attitude and of atmosphere as well as the lightness of the strokes.

Lovers

———

Gustav Klimt, 1914

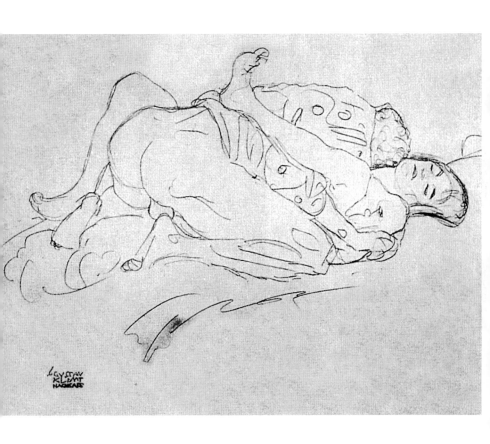

145

Pascin never ceased to dream about a bewitching, sensually Baroque world, an imaginary place where everything is pure enjoyment and whose yearning image he always carried within him. He tried to feel his way back to this image in the brothels of Paris, but also those of Spain, North Africa and America.

Semi-Nude Lying

Gustav Klimt, 1914
blue pencil, 37 x 56 cm
Historisches Museum, Vienna

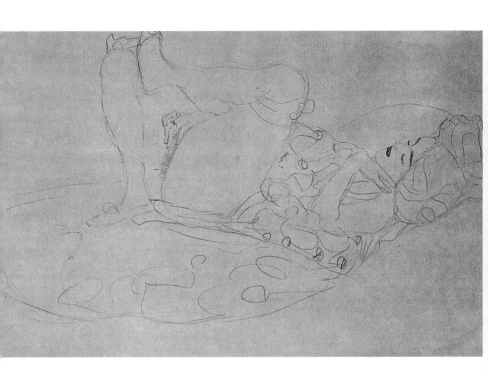

147

His preference for the subject of the "Prodigal Son among the Harlots", which gave him the pretext to describe uninhibited orgies in a brothel, had a biographical background: His father, shocked that as a young man he had already made obscene drawings in brothels in his home town, ordered him to change his name. Thus, henceforth Pincas signed himself Pascin.

Two Girls (Lovers)

Egon Schiele, 1914
graphite and gouache on paper, 31 x 48 cm
private collection

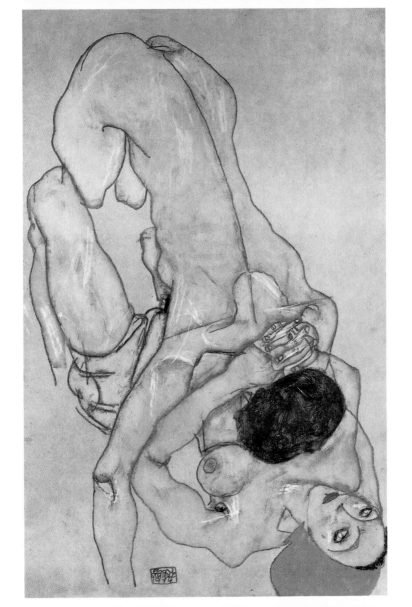

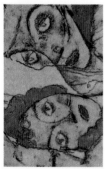

In 1905 Pascin, who had been born in Vidin, Bulgaria in 1885, moved to Paris, where he was warmly welcomed by the painters of Montparnasse, the Dômiers. During World War I he emigrated with his lover, Hermine David, to America, where he married her and became an American citizen.

Coitus

Egon Schiele, 1915
graphite and gouache on paper
31.6 x 49.8 cm
Leopold Museum, Vienna

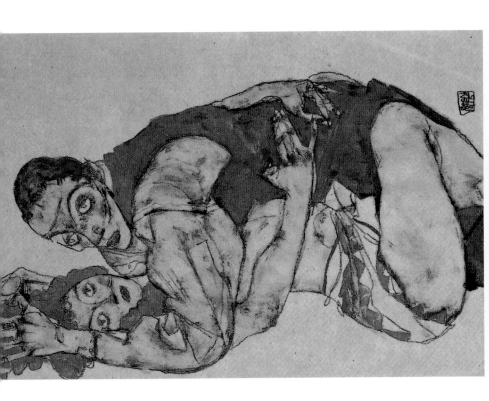

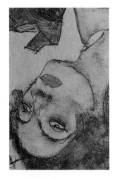

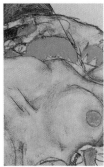

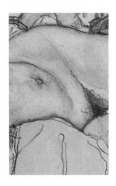

In 1923 he returned to Paris. In the intervening years he had become wealthy and internationally famous; he loved the night and night-time festivities, and liked quoting Flaubert's: "Why complain about life while a brothel still exists in which you can console yourself by making love!"

Two Girls, Lying Entwined

Egon Schiele, 1915
graphite and gouache on paper, 32.8 x 49.7 cm
Graphische Sammlung Albertina, Vienna

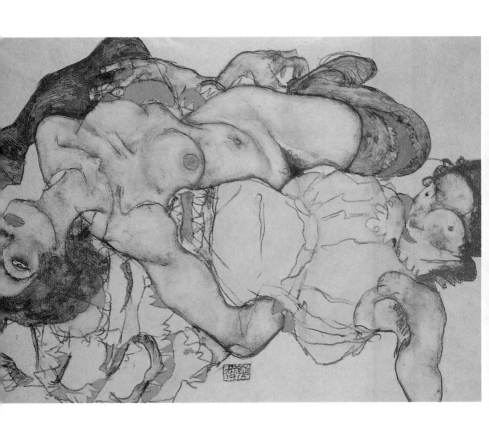

One came across him in all the brothels in Paris; he was always smartly dressed, wearing a black suit and a white silk scarf. Pierre MacOrlan reports that in the brothels he used to sketch the girls on the white silk lining of his expensive English bowler hats. His models, Pascin claimed, were never vulgar, but "dignified even in vice... as I am". Hermann Bing, who was a friend of Pascin's, reported:

Two Girls Embracing
───────────────────

Egon Schiele, 1915
graphite, watercolour and gouache on paper
48 x 32.7 cm
Szépmüvészeti Múzeum, Budapest

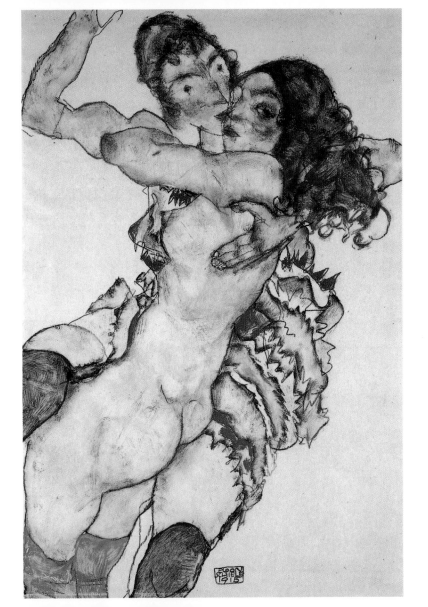

"Whether standing, sitting or lying – he was constantly occupied in completing sketches... without troubling to use materials designed for this purpose. Paper tablecloths, menus, cigarette-packets... all these surfaces seemed to attract his pen, his brush and his pencil with irresistible power.

Female Nude, Wearing Lingerie

Gustav Klimt, 1916-1917
graphite, 37 x 56.4 cm
Vienna

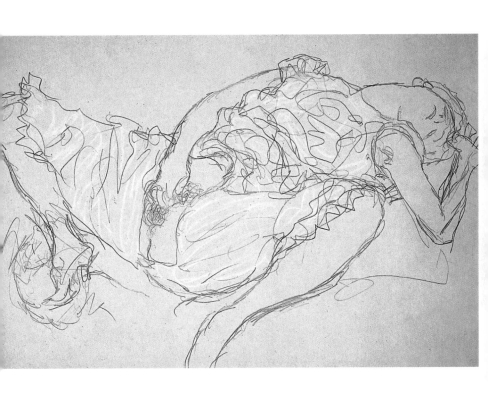

As artistic instruments he simply used whatever was at hand. He would sometimes use thin ink with soda-water; he also took advantage of the carbonized remnants of a burnt matchstick – even the coffee grounds that remained in the bottom of a cup...

Woman Seated with open Thighs

Gustav Klimt, 1916
graphite, white highlights, red pencil
57 x 38 cm
private collection

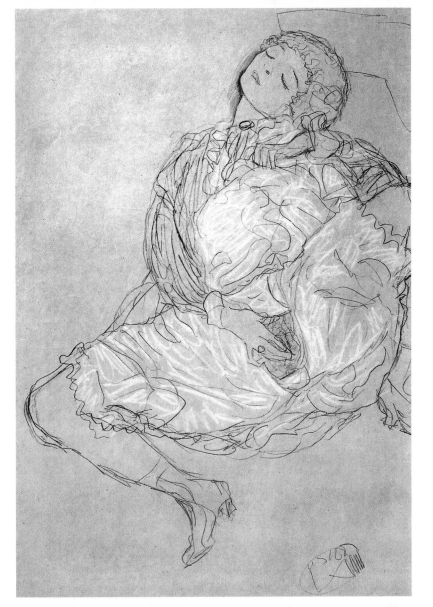

159

He was exceptionally talented. Often he would give his drawings to people who just happened to be there."

His work is a hymn to the "free", the venal love that brings the genders and races together in dissolute bacchanals. In these orgies, as Cabane writes:

Reclining Girl in Dark Blue Dress

Egon Schiele, 1910
gouache, watercolour and pencil
with white highlighting, 45 x 31.3 cm
Private collection, Courtesy St Etienne Gallery
New York

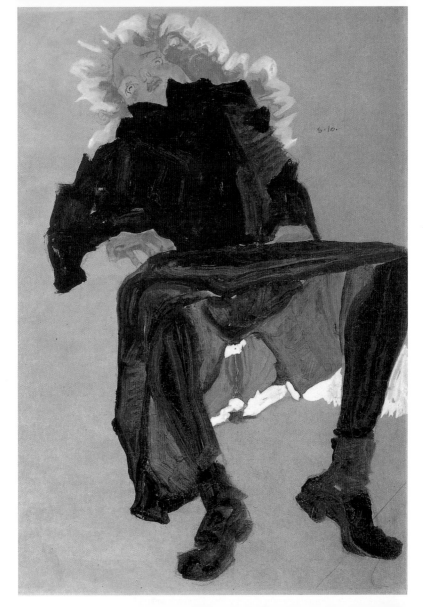

161

"...the 'eternal Jew' from the darkest corners of Europe [finds] an antidote to loneliness, suffering and the torment of living. To his nymphs, whom he treats with exquisite courtesy, he transfers his feverishness, his disappointment, his annoyance at life, but also his sensitive kindness."

Reclining Girl

Jules Pascin, 1920
orignal watercolour, 29 x 26 cm
Israel Museum, Jerusalem

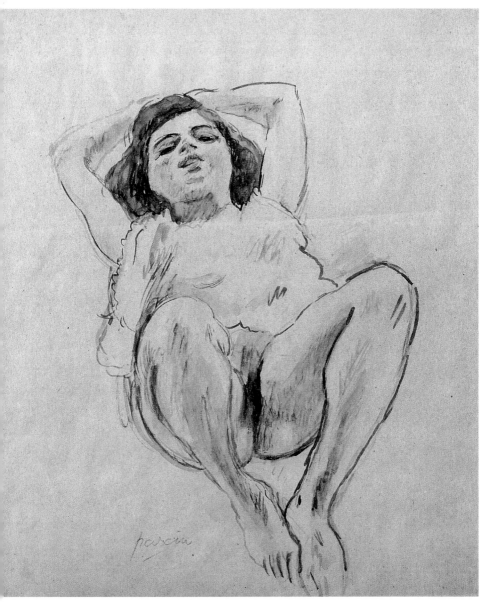

In his assessment, the art historian Wilhelm Hausenstein emphasizes – with an anti-Semitic undertone – the morbid and world-weary elements in Pascin's work; at this time – 1913 – Pascin was still a young man:

"For his style there is only one word: lecherous. It does not have a powerful lustfulness; its lasciviousness is squashed, peering at you askance, oily.

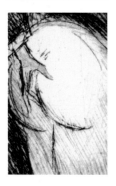

Erotic scene

———————

Marcel Vertes, 1938

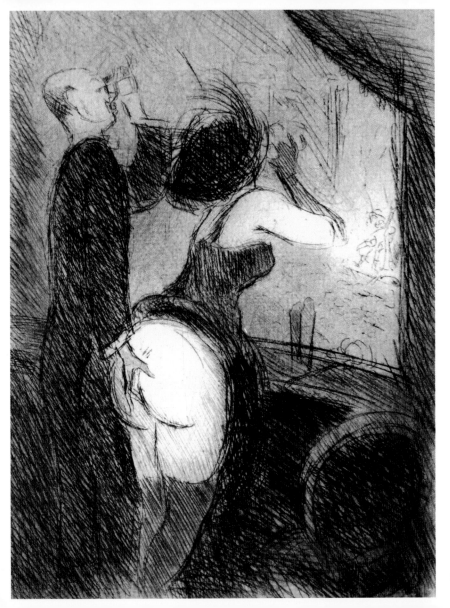

But despite all these qualities – and precisely because of them – it represents an essential form of our times. With an incredibly productive – one might really say – formative vileness, it gives the foul and withered pictures in which people grow out of the soil like vulgar flowers on a marshy or trodden-on meadow – a florid breath of the Rococo.

Brothel Fantasy
—————————
Rudolf Schlichter, early 1920s

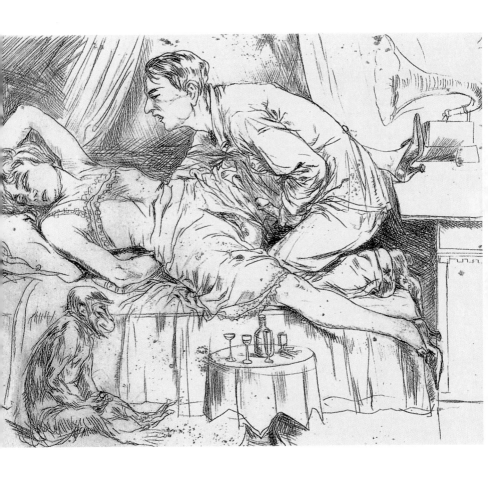

His palette contains pink, pale blue, lilac, tea-rose yellow, and sea-green – just like a Boucher or a Fragonard. Vulgarity becomes a select, artistically distinguished formula; it develops into a free-flowing arabesque.

Female Semi-Nude

Berthomme de Saint-André, 1927

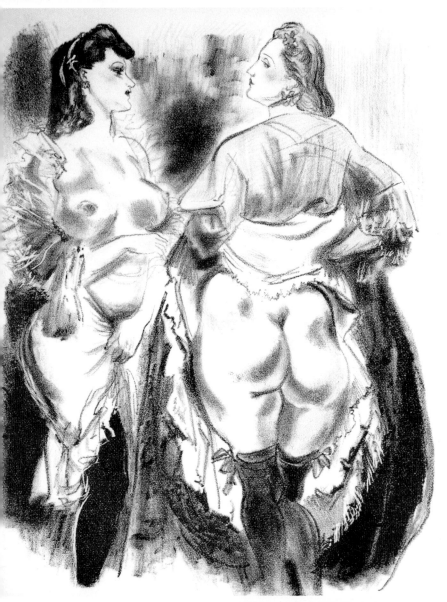

Pascin provides the impossible: the inno-
cence of perversity, the floweriness of vice, the
naivety of absolute corruption, the charming
features of a totally bawdy world, the pure
candor of insect-like eroticism in the brothel."

Caress

———

Jules Pascin, 1925
pencil, 35 x 31 cm
Mr and Mrs Albert Rambert Collection

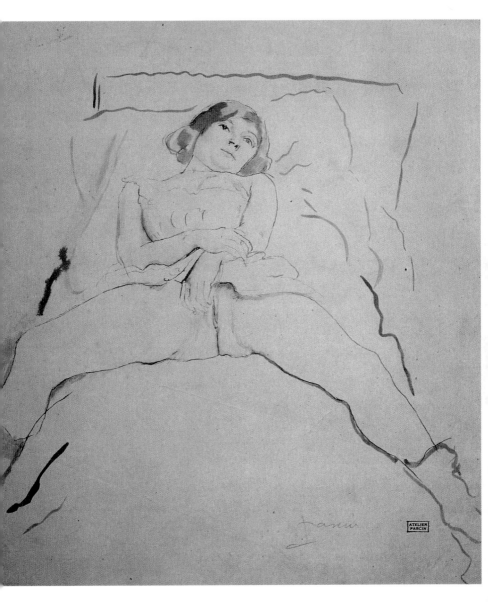

The amorality of this artist made it especially hard for German art critics to be entirely fair to him. Even in the Bilderlexikon der Erotik (Illustrated Encyclopaedia of Erotica), 1929, his entry reads:

"Social decay, evil-smelling public houses, girl-traffickers, suburban prostitutes – a kind of 'Bohème-Rococo in the Montmartre-milieu' are his subjects, redolent of rottenness, syphilis and the madhouse.

Erotic Scene

Jules Pascin, watercolour wash, 1927

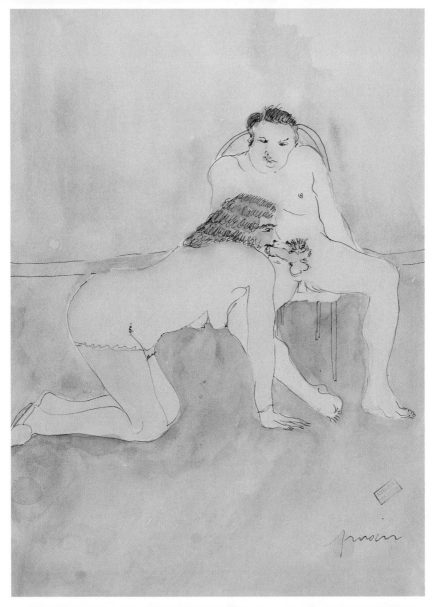

173

Even so, this completely amoral artist knows how to coax a delicate and tender beauty, full of fine gradations, out of his milieu. He is an exceptional draughtsman – full of gentle colourfulness in both his watercolours and oils, and, despite all the cynicism which his exhibitionistic character never denies,

Untitled

———

André Masson, lithograph for *Story of the Eye*
by Georges Bataille, 1928

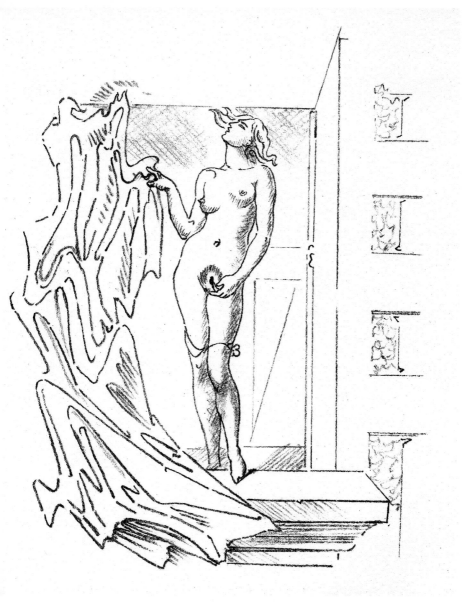

he knows how to make a new kind of flower blossom on this cultural dungheap." This assessment of Pascin is not without ambivalence. On June 2, 1930, tired of life, in his atelier on the Boulevard de Clichy, Pascin slashed his wrists.

Homage to André Masson

Jules Pascin, watercolour, 1928

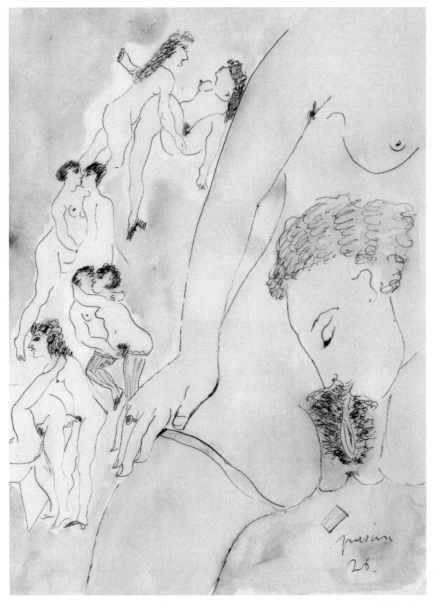

177

Egon Schiele (1890-1918)

Schiele's style is characterised by the voluntary deprivation of the shapes and the sobriety of the contents in which the subject detatches itself from the background. Drawing is particularly important to the artist partly because of his allusiveness and spontaneous side and all the more expressive in that they are coloured.

Homage to Mario Tanzin

Jules Pascin, watercolour, 1928

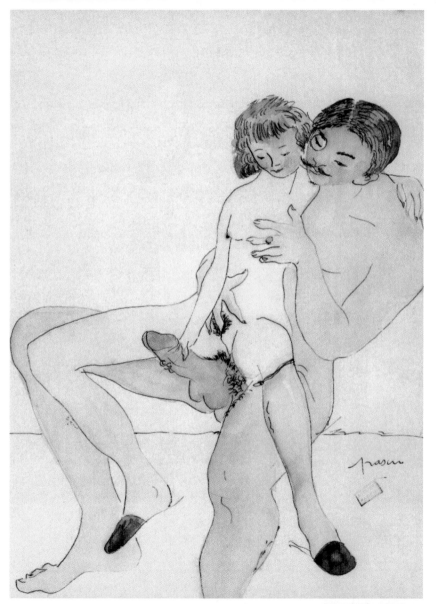

Fascinated by the human body Schiele would produce numerous nudes in positions which appeared more and more provocative, often exposing the genitals.

With a few lines, Schiele sketches the outlines of the body on paper. A thigh is reduced to two lines.

Nostalgia
———

Jules Pascin, 1928
pencil, 47 x 62 cm
Mr and Mrs Albert Rambert Collection

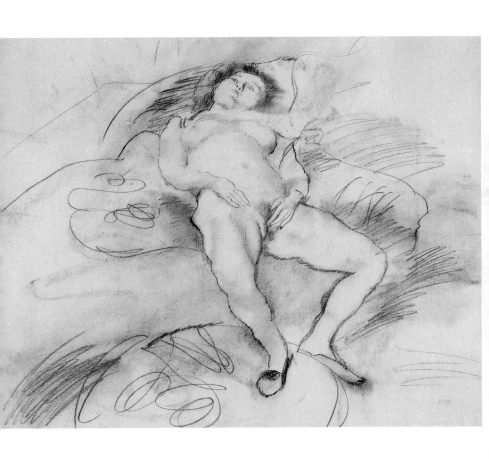

181

The stroke is dynamic, grows fainter, following the structural ductility of a fast thrown-in movement. Jagged, with hard angles he loves the bone structure. Schiele's stroke becomes calligraphy, which captures the body's expression with just a few lines.

Erotic Scene

André Masson, lithograph for *Story of the Eye*
by Georges Bataille, 1928

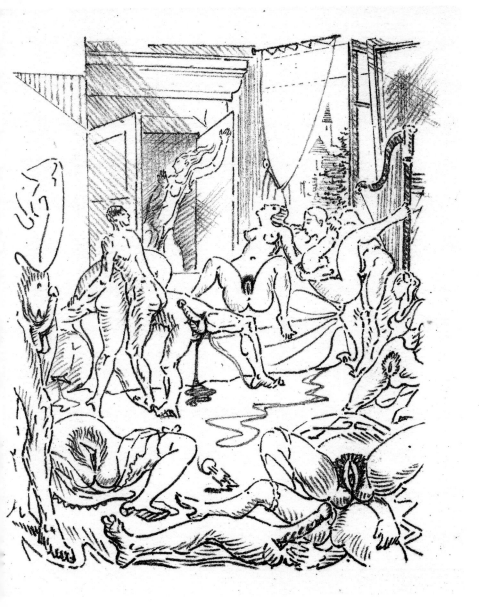

Yet in contrast to the reluctant bony aspect of the shoulders and pelvis is the round diffraction of the chest, orange nipples and vulva become wounds. The physiognomy of his models, however, remains anonymously phantom-like, the button eyes could sooner belong to a doll, which could be any woman.

Erotic Scene

Jules Pascin, drawing from *Erotikon*, 1933

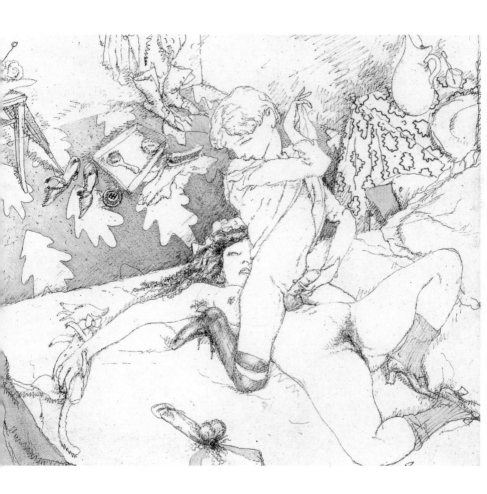

The body posture is directed at the gaze of the viewer, before whom she exhibits her genitals. Peculiar, however, is the splayed gesture of the hands; these appear intractably hard and therein call to mind the hands of Schiele.

Coupling

Pablo Picasso, 1933

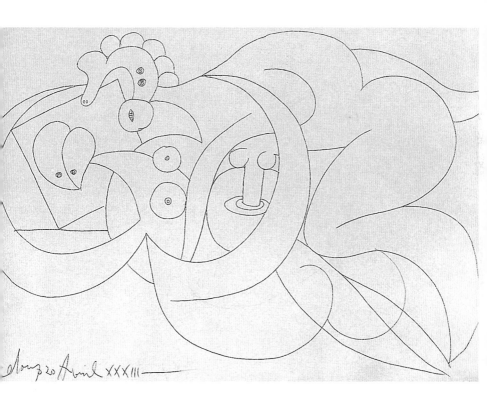

douz 20 Avril XXXIII —

André Masson (1896-1987)

Masson produced a series of drawings in favour of his "automatic" drawing technique. The freedom of his drawings based on the tuning into and the expression of unconscious desires, and on automatism all created an astonishing type of drawing based on the theme of desire all in total rupture with the usual modes of expression.

Coupling

Pablo Picasso, 1933

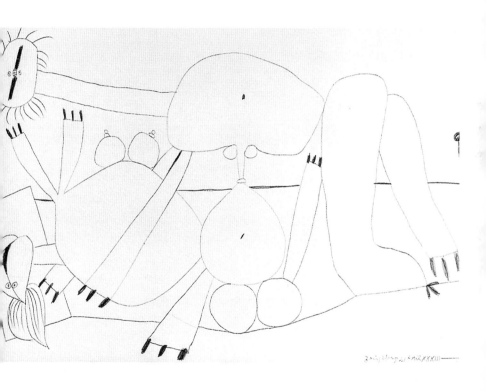

Georges Bataille's novel l'Histoire de l'Œil (Story of the Eye) was illustrated not only by Bellmer but also – as early as 1927 – by André Masson. The idea of the erotic as an ontological tragedy also fascinated him. Masson, the "rebel of Surrealism", as he called himself, still counts as one of the leading Surrealists in France.

Erotic Land
———————

André Masson, 1939
pen, 31.5 x 49 cm
Louise Leiris Gallery, Paris

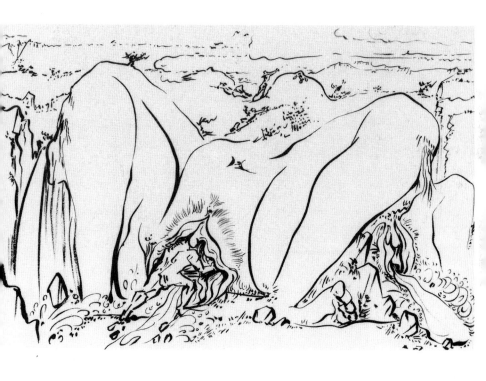

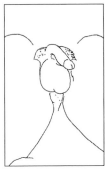

From the early 1920s he was one of the spokesmen and campaigners – along with the theorists André Breton, Georges Bataille, Georges Limbour, and Michael Leiris. Together with Max Ernst, Juan Miró, Alberto Giacometti, and Yves Tanguy – among others – he was an object of artistic discussion.

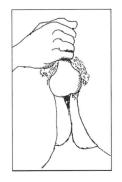

Boy in bed

Lucian Freud, 1943
ink on paper
private collection

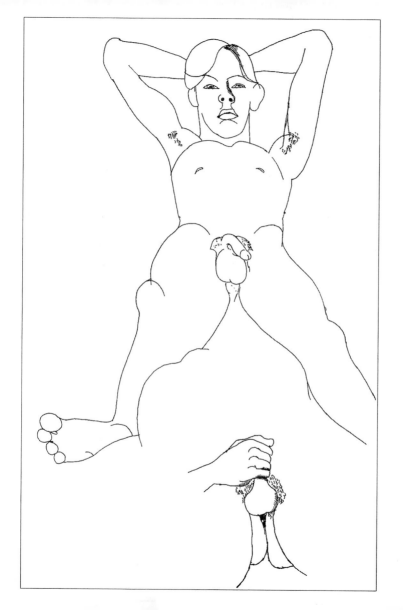

193

"The most important thing", he confessed, "was to show in an emotional way the very deepest things one carried inside one: the phantasms, the desires, everything that came out of one's inner space." In his work Eros and Thanatos fought a remorseless battle.

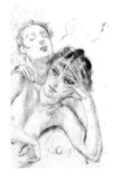

Nude
—
Alméry Lobel-Riche, 1936

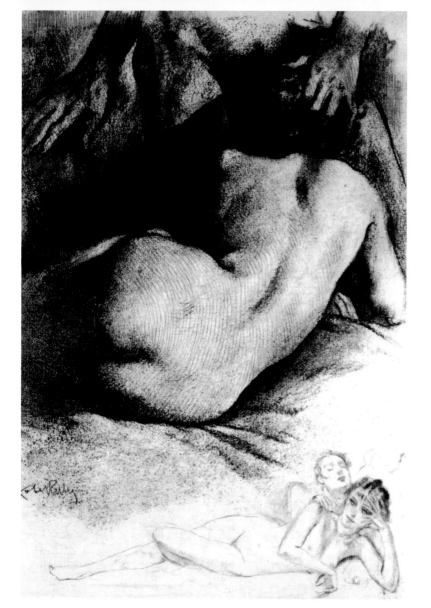

He drew inspiration from areas of power and violence; for him sexual union and power are synonymous. Pansexually, he transfers this struggle to humans, animals and landscape. He sketches out a dramatic cosmogony of warm embraces and intertwinings, whose origins lie in the chasms of the subconscious.

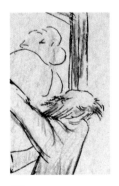

The Critic

Laszlo Boris, 1921

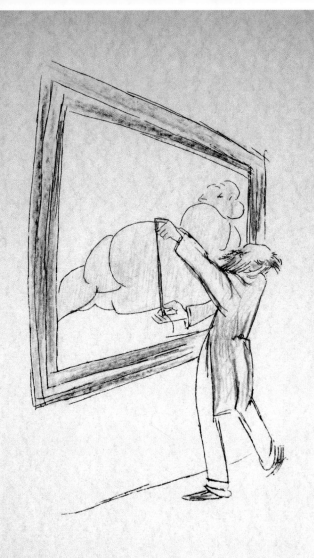

"The erotic is the keystone of all my painting", he confessed in a conversation with the art historian Pierre Cabanne. There is hardly one of his works which does not at the same time give visual form to a deeply gloomy vision, albeit one coloured by enthusiasm.

Nude

———

Félicien Rops, c. 1890

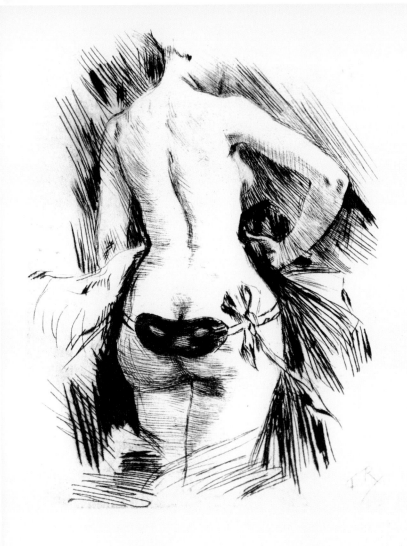

Masson confessed: "To go out of oneself into an orgy, to experience dangerous things, to abandon oneself to drunkenness, to step onto the threshold of death – all this has always fascinated me." For him the erotic is the way to break down the boundaries of the ego. In 1925 Michel Leiris introduces Masson to Georges Bataille,

Union X
———

Jean Dubuffet, 1949
goose quill and indian ink, 27 x 21 cm
private collection, Paris

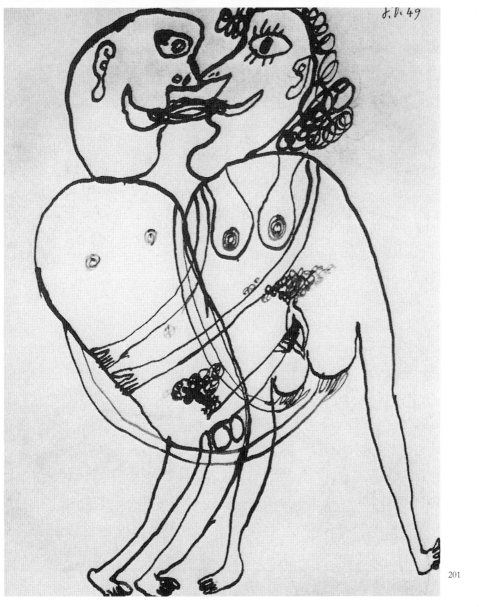

201

who suggests he illustrate the Histoire de l'Œil, which Bataille had written for his publisher in a few weeks. Early childhood perversion, violence, and aggressiveness are the basic subjects of this work, which Susan Sontag counts among the chamber-music prime exhibits of 20th century erotic literature.

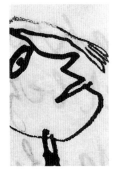

Couple

Jean Dubuffet, 1950
lithograph after the ink drawing, 28.1 x 22 cm

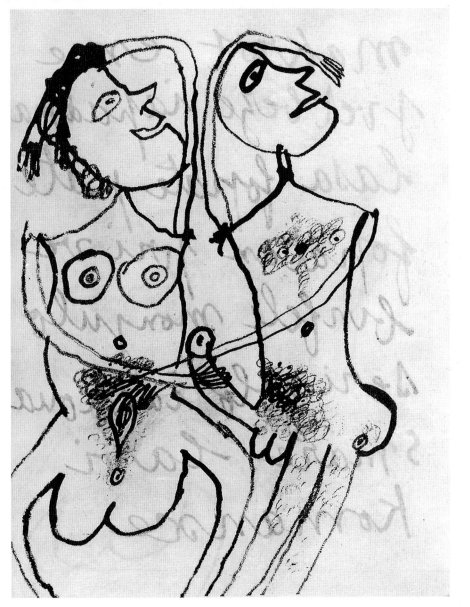

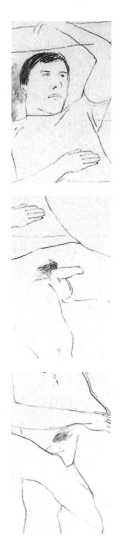

Bataille's influence can be felt all through Masson's œuvre. Breton, on the other hand, would never admit how much Bataille fascinated him with his accounts of Sade and the erotic. He once remarked to Masson: "Bataille is the only real Sadist!" Yet he reproved him for not having confined himself to the purely spiritual but putting his theories into sexual practice.

Dale and Mo

David Hockney, 1966
blue pencil on paper
private collection

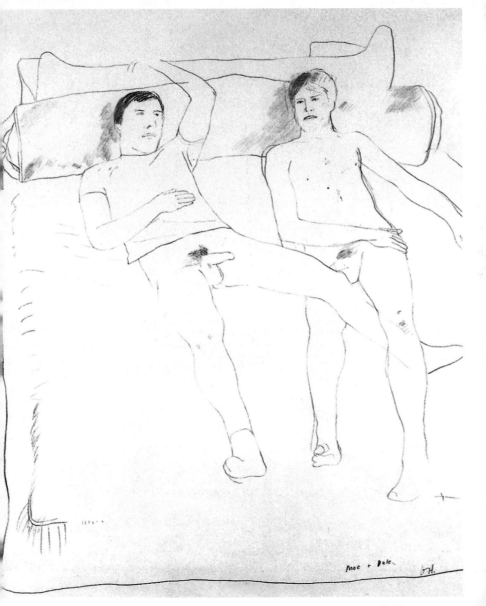

Mo & Dale. DH.

Masson, who was aware of Breton's puritanical leanings, never showed him his erotic drawings. "For Breton", Masson said to Cabanne, "the erotic was like a religious need. For him it served three purposes: release of instincts, asceticism, ritual." Masson would have preferred to call his erotic drawings "Pripaic drawings" – Priapus was the god in ancient Greece who not only embodied virility but also the fruitfulness of the earth.

Erotic Scene

Hans Bellmer
illustration from *Little Treatise on Morals*, 1968

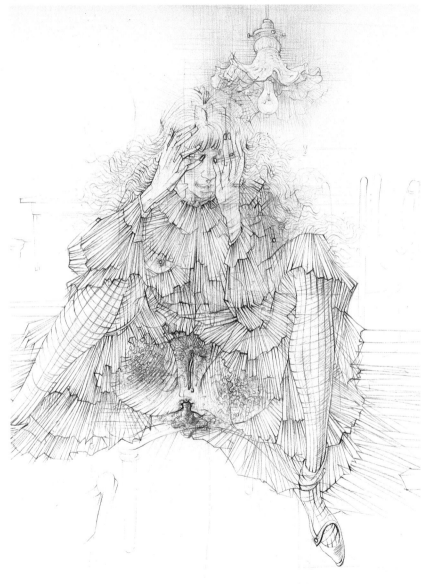

207

He was the god of gardens, vineyards, and procreation. In Masson's Priapic festivals the god merges with nature.

Masson's artistic language – as with Bellmer – totally matches his impulses: line, rhythm, form and colour feast on the flowing movement of his emotions. Fluctuations, cadences, leaps characterize his style in painting and drawing, preventing the subject from becoming too rigid.

Erotic Scene

Hans Bellmer,
illustration from *Little Treatise on Morals*, 1968

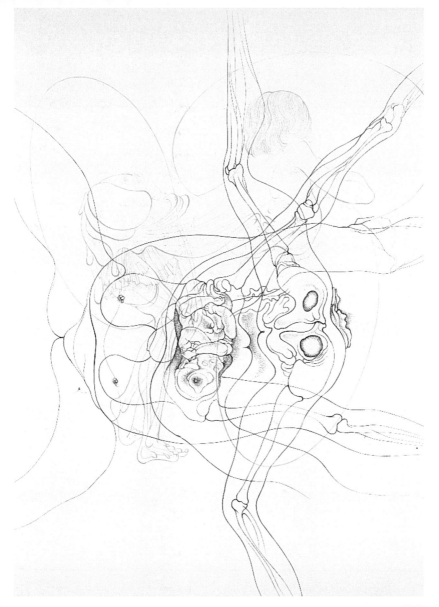

209

His line alone transforms everything into the erotic; he is the seismograph of underworld forces.

An exhibition of his erotic drawings in the "Galérie du Chêne" in Paris in 1946, for which Georges Bataille provided an accompanying text, was closed by the police after a few days.

Erotic Scene

Hans Bellmer, illustration from
Little Treatise on Morals, 1968

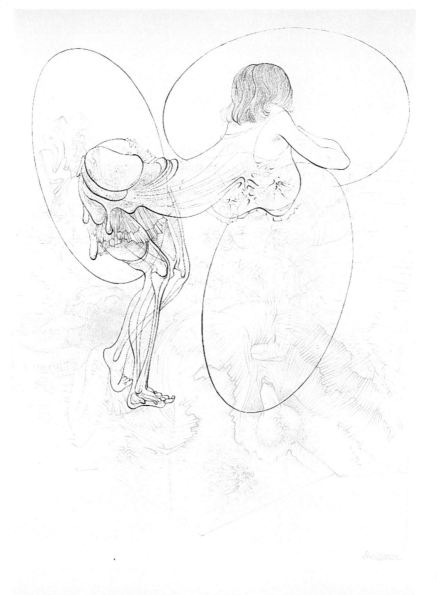

Not until 1961 were the 22 Drawings on the Subject of Desire, which Masson had completed fourteen years earlier in one day, published. The introduction is by Jean-Paul Sartre. Erotic tumult and fantasy orgies are also the subjects of the drawings and oil paintings which Masson created between 1968 and 1970, and which were exhibited in late 1970 in the Galérie Louise Leiris.

Erotic Scene

Hans Bellmer, illustration from
Little Treatise on Morals, 1968

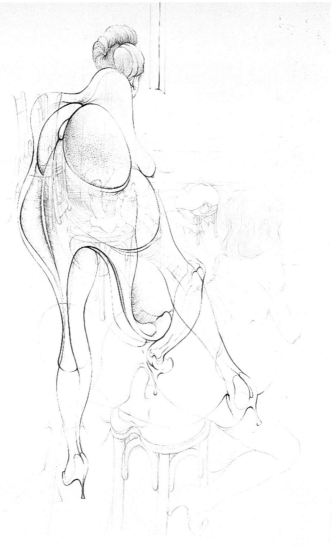

Bellmer

In 1976 a major retrospective of Masson's oeuvre was held at the Museum of Modern Art, New York – and in the following year this was shown in Paris.

Alongside Bellmer, Masson is the most erotic of all Surrealists.

Erotic Scene

Hans Bellmer, illustration from
Little Treatise on Morals, 1968

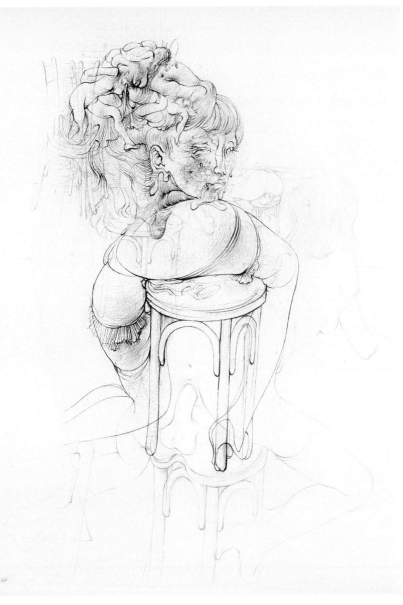

Jean Dubuffet (1901-1985)

Dubuffet executes drawings of images which are voluntarily simple and primitive, even clumsy-looking at times. Thus he creates his own world, free from the principles and values of cultural art and of which certain pieces provoked scandals.

Erotic Scene

Hans Bellmer, illustration from
A Short Treatise on Morals, 1968

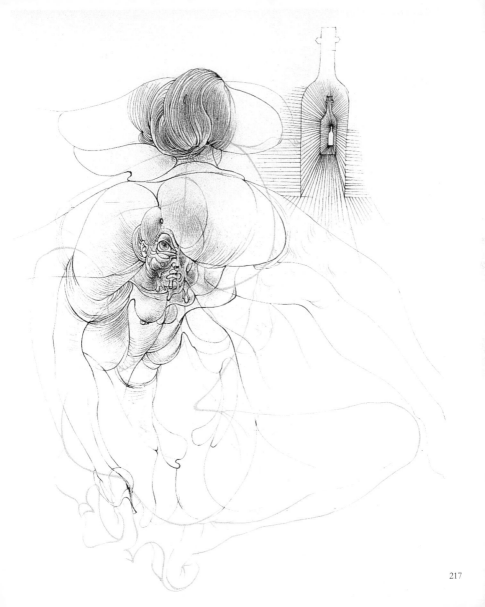

217

Hans Bellmer (1902-1975)

The troubling erotic imagination of Bellmer is witnessed in his drawings. The freedom of his lines, not only precise but subtle, the vigour of his hatching and furthermore the use of white places his drawings in the traditional domain of art.

Erotic Scene

Hans Bellmer, illustration from
Little Treatise on Morals, 1968

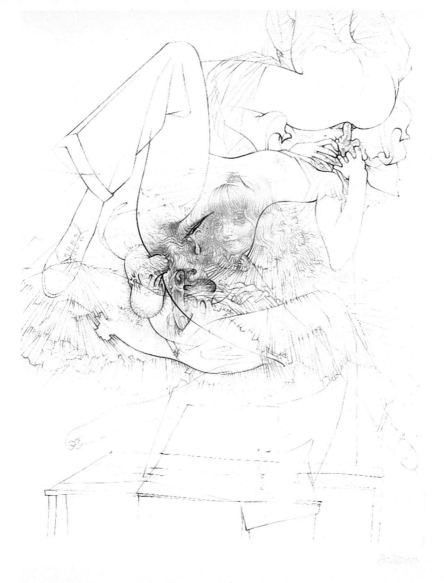

However, his drawings which concentrate on women explore all the aspects of eroticism where all the fantasies of voyeurism, as well as the anatomical details, are excited. Pushing out the boundaries, broadening the space that is visible to use, the integration of different zones of our consciousness, which are usually taboo areas – all this is also Bellmer's Surrealist agenda. His Anatomy of the Picture penetrates little explored psychic-physical border areas.

Erotic Scene

Hans Bellmer, illustration from
Little Treatise on Morals, 1968

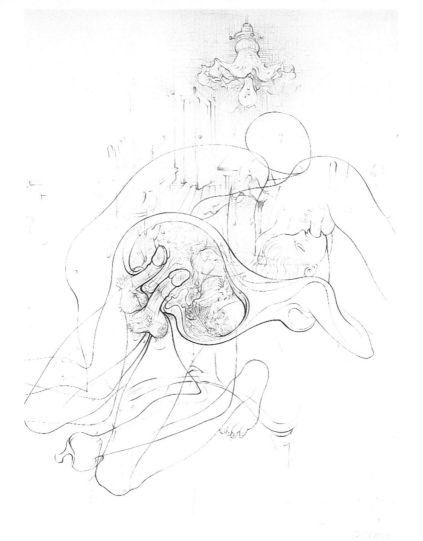

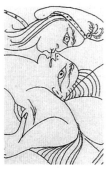

His knowledge of the psychic structure of the physical and the continual interpenetration of both zones as well as his theory of the "physically subconscious" are without parallel. In his subtle drawings we see the visible co-existing with the invisible, the actual with the virtual, the real with the possible.

"Bellmer's drawings", wrote Wieland Schmied, "are never just superficially erotic – in the sense simply of isolated details.

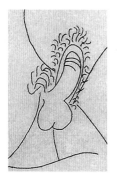

Raphael and the Fornarina

Pablo Picasso, after Ingres, from the *Suite 347*
4 September 1968
etching, 25 x 32.5 cm
Louise Leiris Gallery, Paris

9.68.I

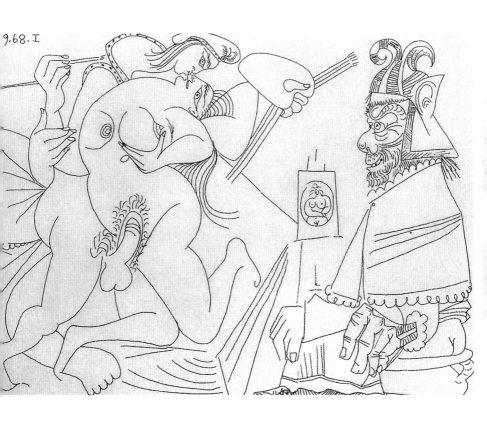

They are erotically charged as a whole. Eroticism determines the structure of his thinking and drawing – it is present in Bellmer's work three times: as subject, as process, and as end product."

His themes: Woman – Mother – Child manifested themselves early on. He was never to get free of them – nor from hatred against his father, that personification of the principle of utility, of the bourgeois and of oppression.

Untitled Drawing:
Erotic Scene

André Masson, lithograph from
Dessins érotiques, 1971, Paris

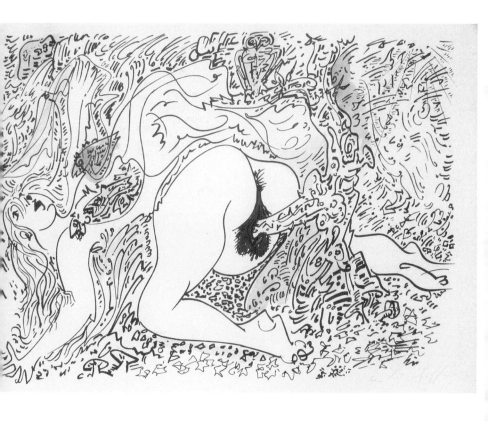

He is obsessed with those creatures he later describes as "the young girls with the large eyes that stand apart".

His courageous creative ventures began in Berlin in 1933, when he started constructing a wooden doll. Some photographs of this doll came into the hands of the Paris Surrealists, and in 1935 were published in the magazine Minotaure under the title: Variations on the Montage of a Little Girl.

Untitled Drawing:
Erotic Scene

André Masson, lithograph from
Dessins érotiques, 1971, Paris

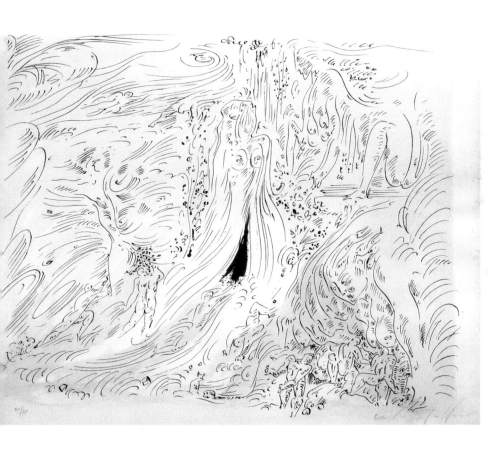

The Surrealists around André Breton and Paul Eluard, around Max Ernst, Dalí and Tanguy were spontaneously enthusiastic about this "accomplished work of convulsive beauty".

In 1938, after the death of his wife, he left Berlin and moved to Paris, where, except for the war and the early post-war years, he lived until his death.

Untitled Drawing:
Erotic Scene

André Masson, lithograph from
Dessins érotiques, 1971, Paris

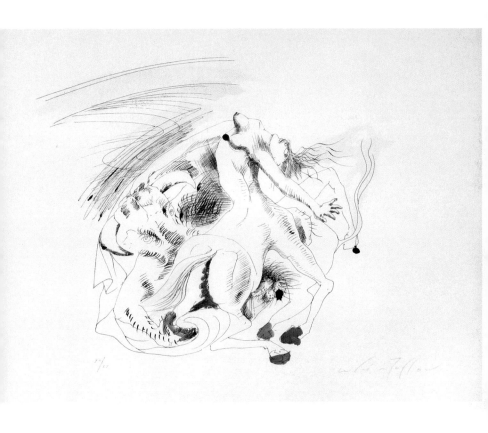

229

In 1941, supposedly in Castres, he threw his passport into a sewer – a sign that he had given up his German citizenship. On the other hand, he never applied for French citizenship. As a true Surrealist, he preferred to be considered "stateless".

Decisive for Bellmer's further development was his meeting with Bataille, whose notion of the erotic is grounded in a recognition of evil. Accordingly, the figure of Sade moves into the dark center of his work.

Untitled Drawing:
Erotic Scene

André Masson, lithograph from
Dessins érotiques, 1971, Paris

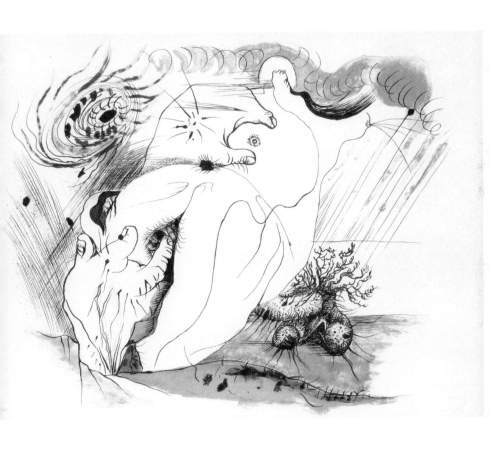

In 1961 he published the 10 copper engravings based on Sade, and in the late 60s his important illustrated book, A Short Treatise on Morals, illustrating writings by Sade, appeared.

"The origin of my scandalous work", Bellmer once said, "lies in the fact that for me the whole world is a scandal."

Untitled Drawing:
Erotic Scene

André Masson, lithograph from
Dessins érotiques, 1971, Paris

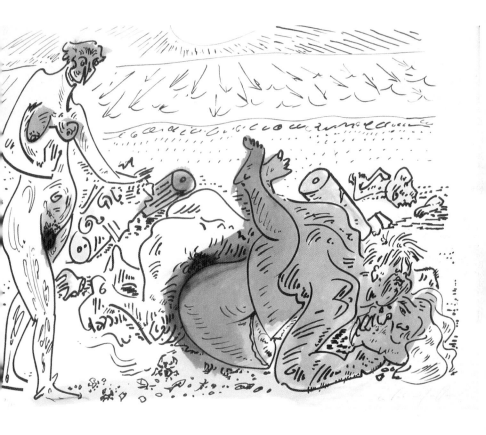

Jelinski wrote of his work: "The shock caused by Bellmer's drawings comes from the fact that Bellmer makes visible to us the connexions which arise obscurely and almost without our knowledge in the shadowy realm between body and soul.

Bellmer's erotic oeuvre is unique insofar as no 'naturalistic' representation is to be found in it – but it is a graphic translation of inner notions, phantasms and sensations, all of which derive from desire."

Untitled Drawing:
Erotic Scene

André Masson, lithograph from
Dessins érotiques, 1971, Paris

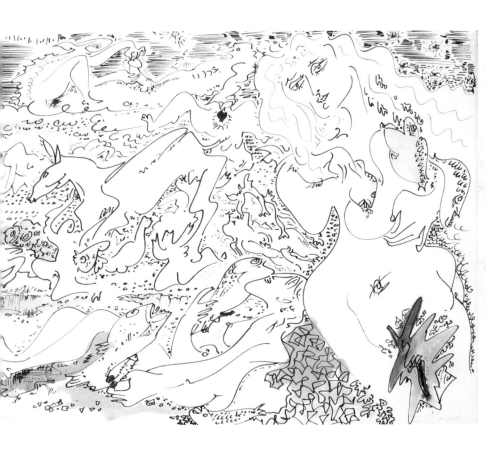

During a longish stay in Berlin in 1953 he met Unica Zürn, who followed him to Paris in 1955. Unica Zürn drew, made etchings and wrote poems, anagrams and short stories. In 1970 she committed suicide, and a growing inner loneliness characterized Bellmer's last years. The first retrospective, put together by Wieland Schmied, did not take place until 1967 in the Kestner-Gesellschaft in Hanover.

Union (Mars and Venus?)

Pablo Picasso, drawing from a sketchbook, 1971

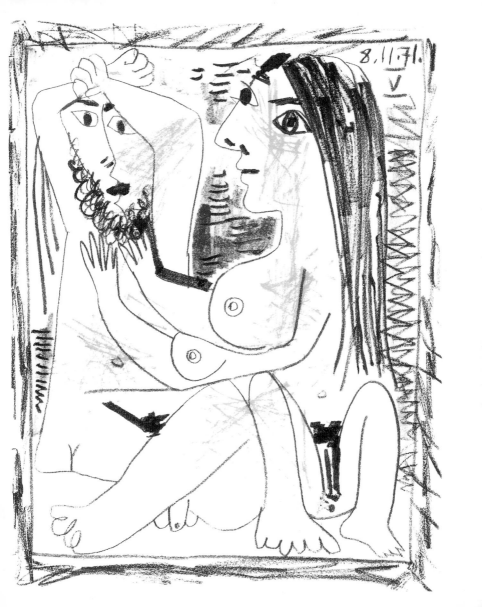

Parallel to this, in the Galerie Brusberg the first major survey of Bellmer's printed graphics was shown – together with an exhibition of drawings and collages by Unica Zürn. Belmer achieved fame and external success only late. Again it was Paris where the obsessive erotic qualities of his work were first recognized.

Union (Mars and Venus?)

Pablo Picasso, drawing from a sketchbook, 1971

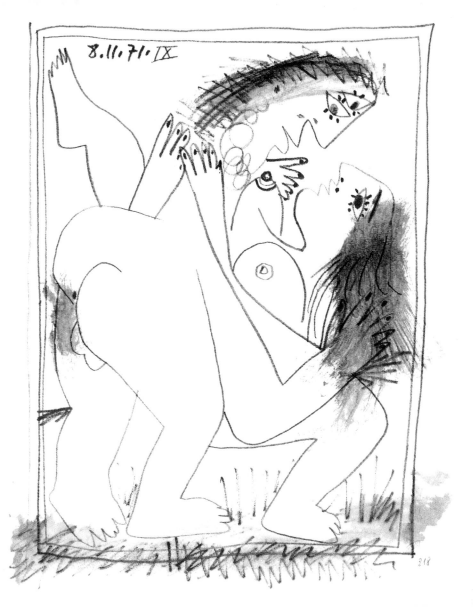

8.11.71. IX

"This work", Jelenski maintained, "contradicts the senseless alternative of form to content, because this erotic work, with its incredible perfection of stroke, does not reproduce rigidified, superficial and appealing aspects of the act of love; instead, it focuses on what is shamefacedly repressed into the domain of the forbidden – i.e. the actual source of that attempt to mingle with the other person – the source that is not merely the basis of vice but also of love."

Union (Mars and Venus?)

Pablo Picasso, drawing from a sketchbook, 1971

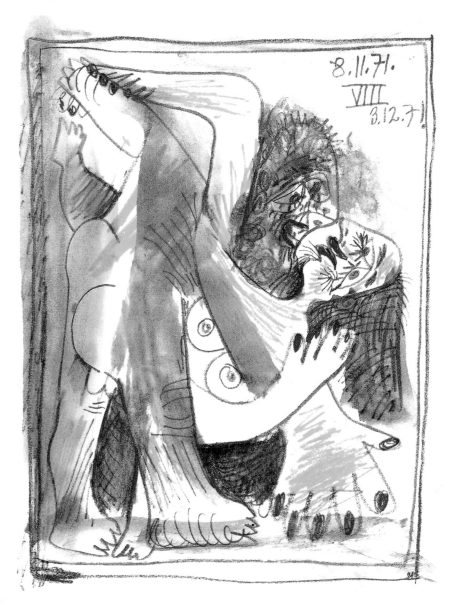

8.11.71.
VIII
8.12.71

The black diamond of Sade's work, which represented the dark counter-pole to the light flirtatiousness of Rococo, glitters once again in Bellmer's oeuvre. Touches of historical continuity reveal themselves in the very upheavals undergone by modern art.

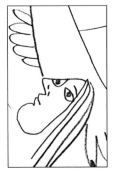

Erotic Scene

Pablo Picasso, drawing from a sketchbook, 1971

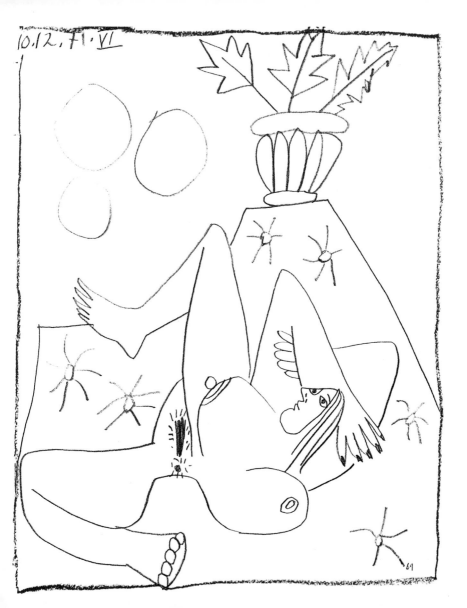

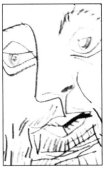

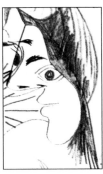

Lucian Freud (1922-)

Freud's works are essentially focused on the representation of the reality of the human figure without any idealisation. From his nude studies, which are sometimes obsessively precise, stirs a troubling bizarreness.

Erotic Scene

Pablo Picasso, drawing from a sketchbook, 1971

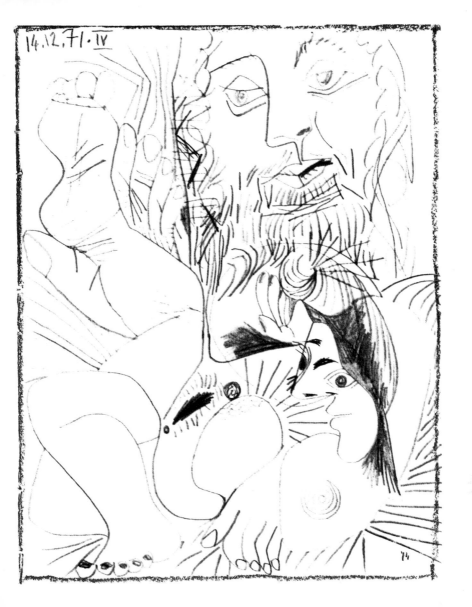

David Hockney (1937-)

Hockney's drawings are mainly autobiographical. After having used a falsely clumsy and naïve approach he would then go and produce drawings with strict contours. The artist places his characters in sterile theatrical settings and gives us a detatched yet comic vision of the world.

Untitled
———

Pablo Picasso, 1971
pencil on cardboard, 21.7 x 31.3cm
Louise Leiris Gallery, Paris

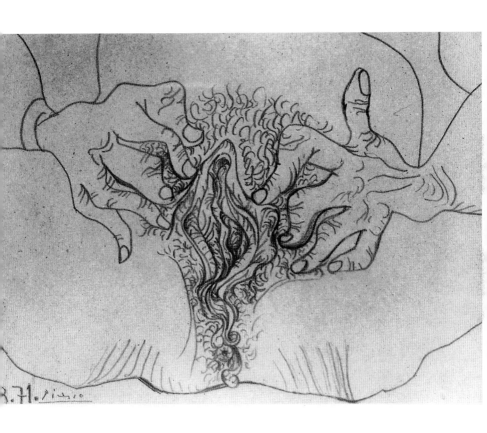

247

Index

U